Pencil Drawing

Michael Woods

Pencil Drawing

Dover Publications Inc., New York

DEDICATION

To Barbara Porter

ACKNOWLEDGMENT

I would like to thank all those who directly or indirectly have contributed to this book, and in particular my many pupils over the last 30 years at Charterhouse. My thanks are also due to Charlotte Stagg for permission to reproduce her drawing (Fig 1), and to my wife, Jacqueline, for typing and checking the manuscript and, above all, for her patient ear.

© Michael Woods 1987
First published 1987
Reprinted 1988, 1989

Library of Congress Cataloguing in Publication Data

Woods, Michael.
 [Starting pencil drawing]
 Pencil Drawing/Michael Woods.
 p. om.
 Previously published as: Starting pencil drawing.
 Bibliography: p.
 Includes index.
 ISBN 0-486-25886-6 (pbk.)
 1. Pencil drawing – – Technique. I. Title
NC890. WBB 1987
741. 2′4 – – dc 19

CONTENTS

INTRODUCTION

Pencil and paper—a partnership assumed and accepted by all. Yet this commonplace duet can also become the most sensitive part of an artist's materials.

To sharpen a good quality pencil, with the smell of freshly cut wood, is one of the pleasures associated with drawing. While some materials can be expensive to buy, a small collection of pencils will not be beyond the means of most people. The pencil can provide the very first drawing marks a child may make (Fig 1), yet, miraculously, in the hands of an artist it can produce an image of great complexity (Fig 2). What lies between is a sequence of discovery and considerable visual reward.

Obstacles like 'I'm no good at art' must be dismissed immediately, for we can all draw. It is not limited to a select, talented few. Of course some may claim to know exactly what great drawing, both old and new, should be like and single out particular artists for praise. But fashions can be very fickle and should not dissuade anyone from trying.

Our own preferences are important. To be able to draw the flowers from your garden, grown lovingly over the year, adds a new dimension to gardening (Fig 3). Similarly, an ancient piece of machinery or an archaeological find (Fig 4), or perhaps the identification of a bird might encourage a record to be made (Fig 5). People, buildings, things—the possibilities are, of course, endless (Figs 6 to 9).

But whatever the subject, it is the marks made by the pencil which should be given much of our attention. While children appear to be uninhibited in what they draw, adults will wish to add conscious control to intuition. Children can also be particularly perceptive in their remarks. When asked 'How do you draw?', one young, budding, artist replied, 'First I think, then I draw my think'. I can give no better advice.

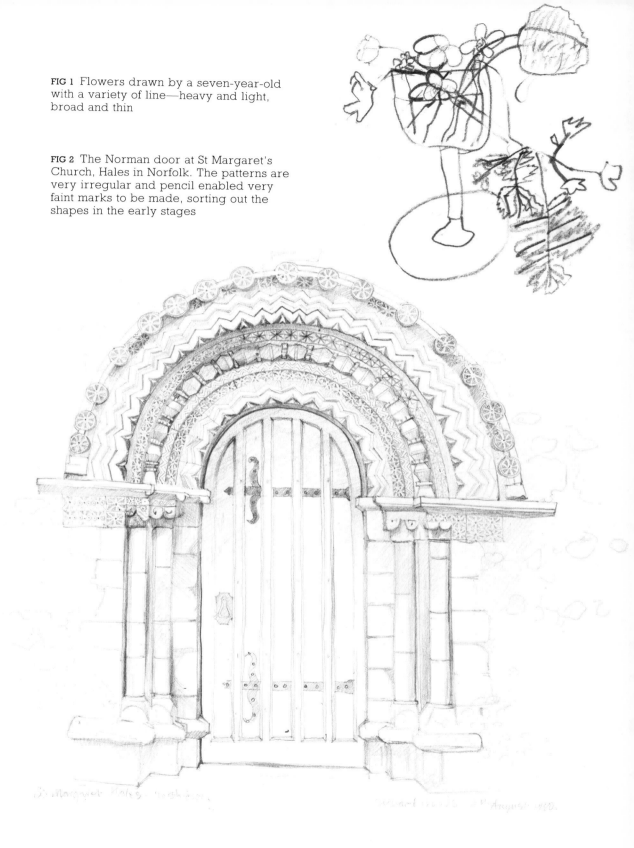

FIG 1 Flowers drawn by a seven-year-old with a variety of line—heavy and light, broad and thin

FIG 2 The Norman door at St Margaret's Church, Hales in Norfolk. The patterns are very irregular and pencil enabled very faint marks to be made, sorting out the shapes in the early stages

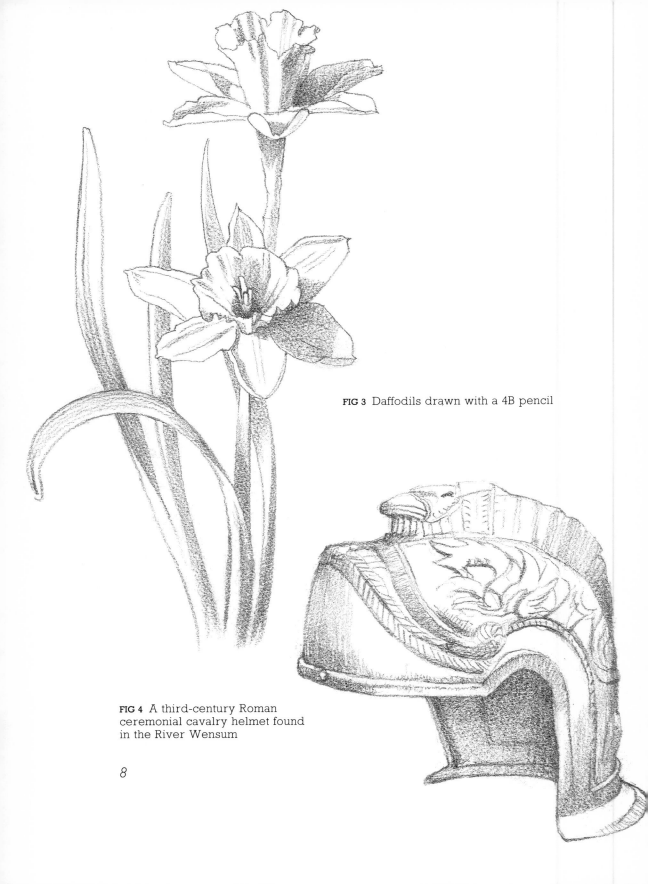

FIG 3 Daffodils drawn with a 4B pencil

FIG 4 A third-century Roman
ceremonial cavalry helmet found
in the River Wensum

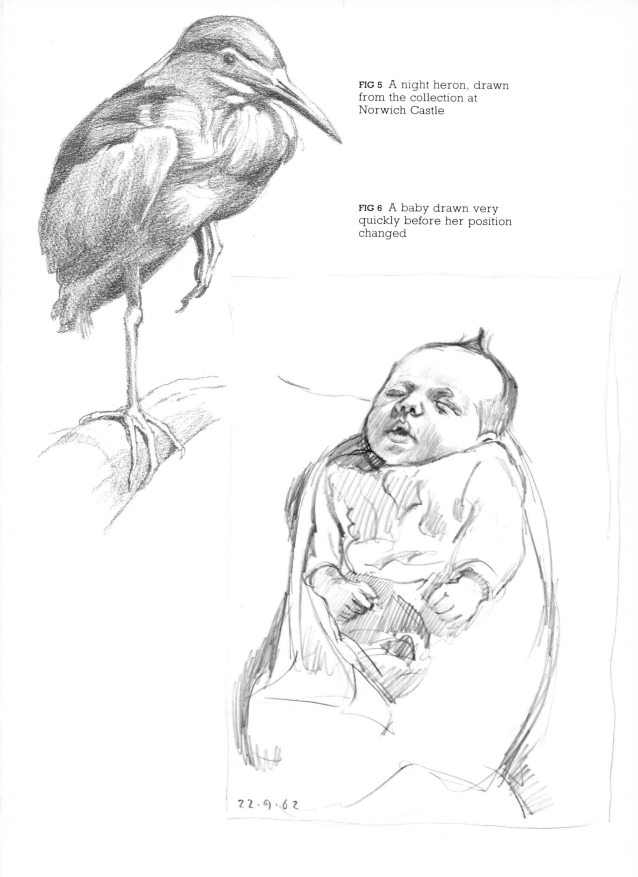

FIG 5 A night heron, drawn from the collection at Norwich Castle

FIG 6 A baby drawn very quickly before her position changed

22.9.62

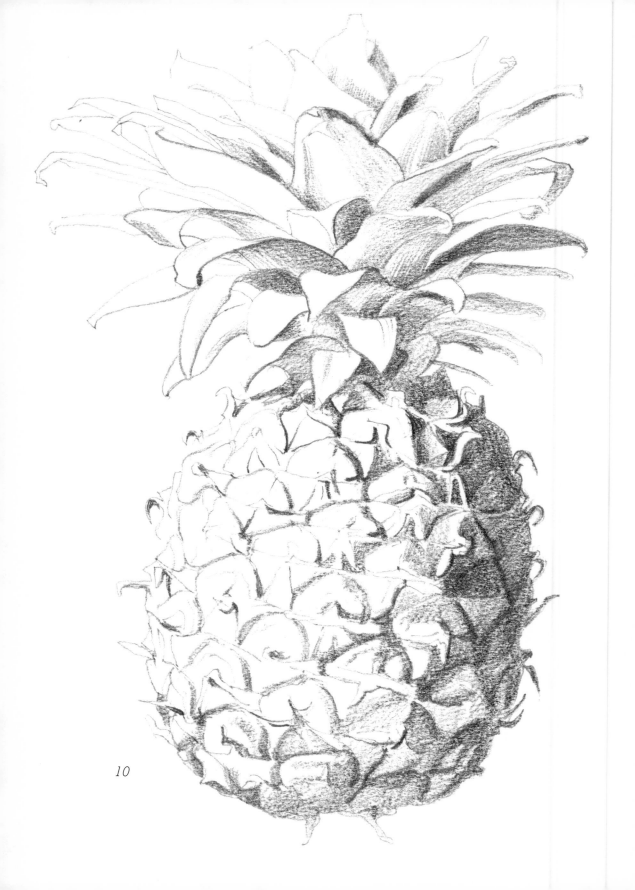

10

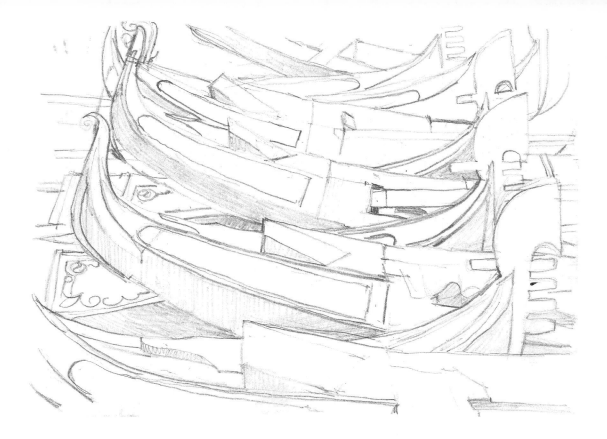

FIG 7 Nature often provides complex shapes, ideal for drawing studies

FIG 8 Gondolas moored in Venice—a page from a sketch book

FIG 9 A sketch-book study made on holiday

11

CHAPTER 1

Which pencil and paper?

Pencils seem to have been developed in the mid sixteenth century. The word pencil comes from *pencillus*—Latin for brush—and the term is still applied to a fine brush for making lines. In fact the term 'drawing' is, in itself, a broad one covering the use of both dry and wet materials.

Originally of pure graphite, a mixture of graphite and clay was subsequently developed and this is still the basis of modern pencil manufacture. Variations in selection of materials, proportion, intensity of grinding and firing, control the quality of the finished 'lead' which is then encased in slats of cedar wood, painted and lettered, thus producing the type of pencil commonly seen today.

An ordinary wood pencil should bear a grade marked on it. Harder pencils have H, the degree of hardness increasing as the related number increases, thus 6H is harder than 2H. These are rarely used for drawing. HB (hard black) is a sort of half-way point, then the Bs get increasingly soft up to 8B. I recommend that you find a local art shop which markets a good quality pencil and stocks its full range. Then initially you can select, say, a 2B and a 4B. By keeping to the same make, the variation in the range will be constant and thus if you want a softer pencil you can gauge the number from those you already have. But if you change the make, a 2B in one may react like a 3B in another.

As pencils get harder the point will not wear away so quickly, but the mark will get paler. As the grade gets softer the point will wear away more quickly, the marks made will be darker and invariably become thicker.

A pencil sharpener does not make a good point for drawing because it does just that—makes a point (Fig 11). Once that point has gone, the round tip becomes blunt and rather insensitive (Fig 12). A far more versatile tip is created by sharpening the pencil with a knife; a proprietary brand with a replaceable blade is best (Figs 13 and 14) because the cutting edge needs to be very sharp. The penknife or pocket knife with a steel blade rarely, in my experience, is sharp enough, and when re-sharpened it tends to have a 'fat' edge which then has to be used at too great an angle to the pencil (Fig 15). The replaceable blade has a hollow ground cutting edge which enables the cut to

FIG 10 A variety of pencils will invariably be collected

FIG 11 A point made by a pencil sharpener

FIG 12 The blunted point of a mechanically sharpened pencil

FIG 13 A useful pocket knife with a retractable blade which is also replaceable

FIG 14 A knife which has a retractable blade, portions of which can be broken off to provide a sharp tip. The whole blade unit is also replaceable

13

be long and lean (Fig 16); a long, chisel-like point is what is required (Fig 17). The length will allow the pencil to be worked with a greater area of lead in contact with the paper, providing a broader line when needed. It will also provide a longer working time before a resharpening becomes necessary.

There are many pencils available which have a retractable lead, but I hesitate to recommend them. My main criticism is that they are difficult to sharpen to a long, flat point, and with those I have tried there was a slight wobble in the mechanical parts which I found distracting. Of course, some may not have these limitations, and one particular advantage they do have is that the working end can be retracted and thus protected.

When it comes to the question of protection, carrying and storage, the simple pencil box takes some beating (Fig 18). Most are capable of holding some six or eight assorted pencils plus a small sharpening knife and a rubber—what more could you want! Smaller containers of various sorts might be brought into use—a spectacle case would do very well or an aluminium cigar tube (Fig 19). Individual pencils can be protected with a metal or plastic cap, some having a clip for location in a pocket (Fig 20).

FIG 15 A pencil with the wood cut at too abrupt an angle

FIG 16 Here the wood has been cut at a long, lean angle producing a long tip

FIG 17 The tip of the pencil has greater versatility when given a slightly broad point like a chisel

14

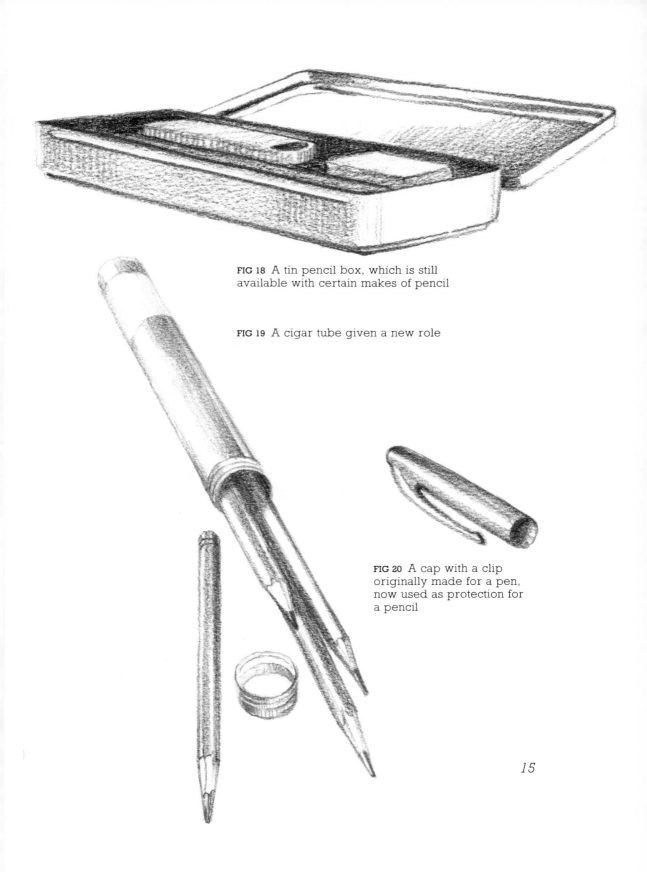

FIG 18 A tin pencil box, which is still available with certain makes of pencil

FIG 19 A cigar tube given a new role

FIG 20 A cap with a clip originally made for a pen, now used as protection for a pencil

15

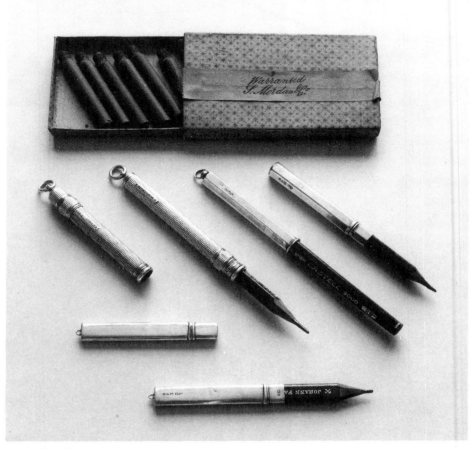

FIG 21 A collection of old silver pencils

Personally I do not think anything can beat the type of pencil holder made around the turn of the century, and still available to those who enjoy searching in antique shops. Frequently made of silver, they fall into three types. One, those which take a standard round wood pencil—or hexagonal—the end of which can be screwed into the holder. It has to be a short stub, but may then be retracted when not in use. Two, the sort which takes only a standard hexagonal wood pencil—again only a short length can be used but this type has a removable cap which, when in use, is pushed on to the base end. Three, a rounded, flat silver case which takes a flat pencil (unfortunately, I think, no longer available unless you track down a rare hoard of refills!) (Fig 21). These old holders are very useful in providing a sharp pencil always to hand; I invariably have one in my pocket together with a small drawing book.

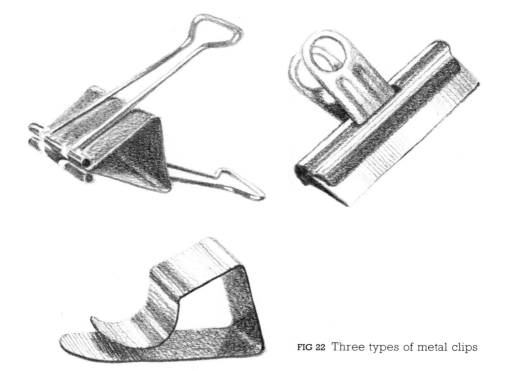

FIG 22 Three types of metal clips

For many other drawing and painting processes special paper is required—for example, for water-colours it has to resist thorough wetting. Not so for pencil drawing.

As long as the grade of pencil is soft enough, typing paper, plain wall-lining paper, brown wrapping paper, ordinary writing paper, can all be taken in for use and they do not have to have a special artistic label. But if the paper is thin, then it will dent easily and sheets underneath will receive marks from the drawing above. When you have tried and experimented with what is immediately to hand, you will be better able to judge what to choose from your local art supplier. It is best to buy single sheets of varying paper types when available and to try them out before committing yourself to larger quantities. If possible, don't let the assistant roll up your paper; it will never lie flat again! If it is a big sheet and you know you are going to use it for experiment, just fold it in four and cut into quarters when at home.

A drawing board can be a decided advantage. Purpose-made wood boards can be rather expensive, but they are made so that they will not warp, twist or split. A really flat piece of anything will do, although surprisingly many materials do warp. However, hardboard, plywood, wall boards, even

thick cardboard, are all possible with care. If you are improvising, do choose the smoothest side, for many modern facing materials have one side textured for adhesion. Whatever you use, I recommend an undersheet to prevent any flaws pressing through onto your actual drawing sheet. A piece of mounting card is ideal and on any of these improvised boards it can well be that spring clips will be more suitable than pins (Fig 22). The one limitation of these is that a small piece of paper can be fixed only at three points when situated on a larger board.

I have never known a pupil of mine to be happy to start drawing without an eraser—commonly called a rubber! I do admit it is a form of security, although to depend on it too much does not help at all. Small and thin is the best recommendation I can give. Try cutting a small eraser diagonally, so providing a finer tip; one is more likely to want to remove part of a single line than vast areas of drawing (Fig 23). I also prefer a white rubber. Some others can leave traces of colour when heavily used, and this seems an unnecessary hazard. Old rubbers can develop a hard skin and this should be pared off. When in pockets and boxes rubbers do collect dirt, so always rub a corner clean on a spare piece of paper before using on a drawing. Putty rubbers are malleable and gather up all they remove, rather than crumbling away; they are good for lifting off an over-dark application of pencil, patting rather than rubbing (Fig 24). Again it is a case for experiment to ascertain preferences.

I have purposely laid out the picture in Fig 25 in three areas. The top part furthest away; the centre area, the middle distance; and the bottom, near foreground. Try using three pencils for a copy of this particular drawing; an HB for the top, a 2B for the middle and a 4B or softer for the foreground. The greyness of the HB will make the furthest part seem far away and in contrast the 2B closer, while the 4B will be both darker and of a coarser line—not least because the tip will blunt quite quickly.

Generally I do not mix the grade of pencils in one drawing, but rather press more gently or more firmly to get a paler or darker tone. But this is purely a personal preference. Try some tests. Draw a set of trials, leaving a gap between each (Fig 26). With each of your pencils in turn, put in some lines both lightly and heavily drawn, and some more solid shading. You will have a sort of chart showing the capabilities of your whole collection and as your personal preference grows, you will be able to select the right type of pencil for a particular drawing—or any mixture you think appropriate.

Any other pencils you acquire should also be given this sample treatment. Coloured pencils of course, but others like charcoal and those with a wax base will all have subtly different characteristics—particularly in handling. Always try pencils on more than one paper type, for it is not fair to condemn a pencil for skidding on a very shiny paper, when really it should be used on a rough, dry surface.

Unintentional smudging of a drawing can be irritating. Harder pencils do not smudge very much, but the softer grades will. To help prevent this, if, having laid out a drawing faintly, the development shading can be made in sequence, with the hand retreating, the least smudging will be caused. Thus, right-handed artists should start top left and finish bottom right, while those

who are left-handed should work from top right to bottom left. In addition a sheet of paper can be placed over areas where the hand may rub. Tracing paper allows the drawing to be seen. But, try as you may, it is a problem and keeping your fingers clean is part of the battle. Once a drawing is finished, a proprietary brand of fixative can be lightly applied which will give a certain degree of protection.

FIG 23 An eraser with a small slice cut from it for finer use

FIG 24 A patch of pencil shading with an area made paler by the use of a putty rubber

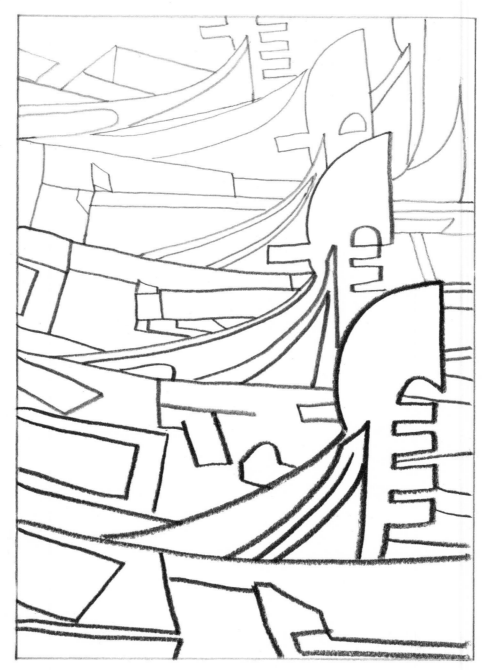

FIG 25 A redrawn part of Fig 8, using three grades of pencil

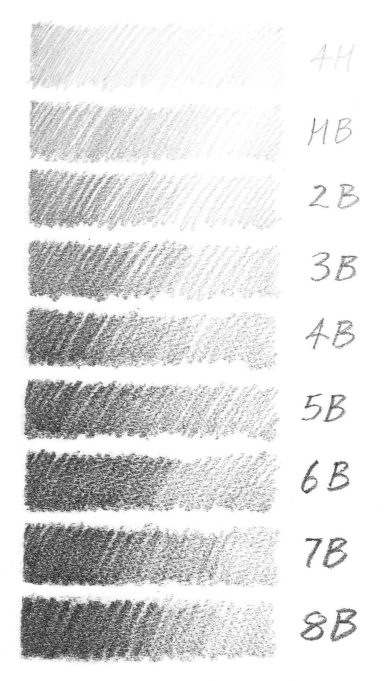

FIG 26 A sample of pencil grades

CHAPTER 2

Just line

There is every likelihood that the way you hold your pencil is perfectly natural and will be right for you. However, it is always worth trying variations for greater flexibility. Instead of holding the pencil right at its tip, consciously try holding it one-third back (Fig 27), half-way (Fig 28), and right at its blunt end (Fig 29). The further back from the tip the grip is made, the greater the reach. This enables the greatest movement of the pencil with the least movement of the hand and helps to prevent smudging.

Moving the whole arm from the shoulder is also a good thing to practice. With only the pencil touching the paper, you may at first seem to lack control, but it can enormously assist the drawing of sweeping curves and a generally broad treatment, as well as keeping the eye from getting too close to the paper! Practise on some old paper (wrapping paper will do) with your softest pencil by writing in 10cm (4in) high letters (Figs 30 and 31).

The real world, of course, is full of colour and movement, while a drawing is just greyish marks on a piece of paper. It is quite easy to get so caught up in the subject that the actual pencil mark is not given sufficient priority.

Economy is often rewarding and in drawing, as in writing, this aspect can be explored by using just lines to describe the subject (Figs 32 and 33).

From a simple still-life group of oranges, and using a sharp HB pencil, draw only a single outline for each of the shapes (Fig 34). Do not shade or change your first decided marks. Rather complete one and then try the whole drawing again. Do not spend more than about five minutes on it. The drawing will readily describe the ball-like forms of the oranges but may look somewhat mechanical, with little life.

In a second drawing vary the thickness of the line very consciously—thin towards the source of light and thicker on the other side (Fig 35). A chisel-tipped 4B will help to provide this variation. You may feel that the second drawing shows more feeling for volume and space than the first.

When this variation of line is used more naturally and instinctively in a drawing, it will be found to have introduced a certain delicacy; in addition the thinner lines are likely to be paler; a soft-grade pencil will tend to make a thin

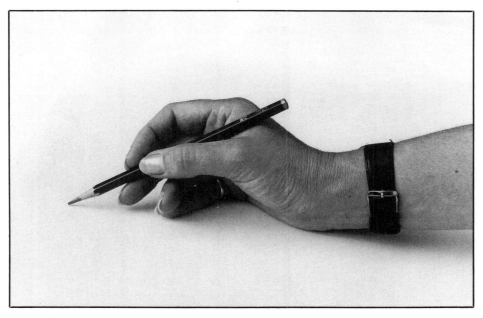

FIG 27 Holding a pencil one third back from the tip

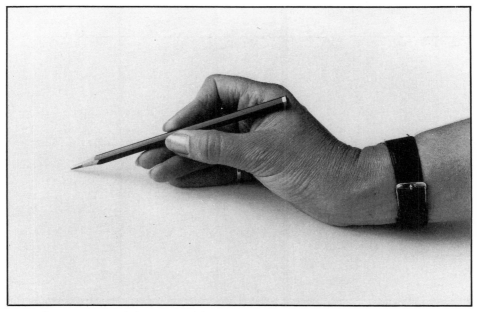

FIG 28 A greater reach is obtained by holding the pencil half-way along its length

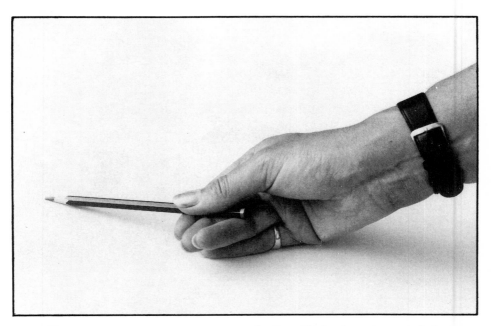

FIG 29 The greatest reach is possible when the pencil is held right at the end. This is particularly useful for shading. Notice how the pencil tip can be made to lie close to the paper surface

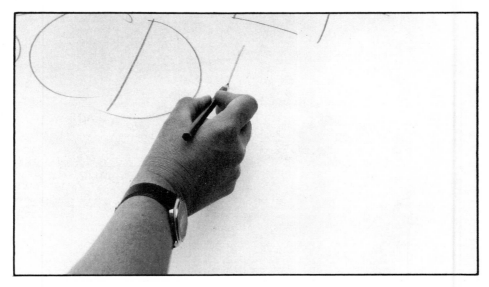

FIG 30 Large, sweeping marks made from the shoulder, not from the finger tips

FIG 31 To begin with you may find it easier to let your little finger touch the paper

FIG 32 Two wooden cable drums drawn with line alone

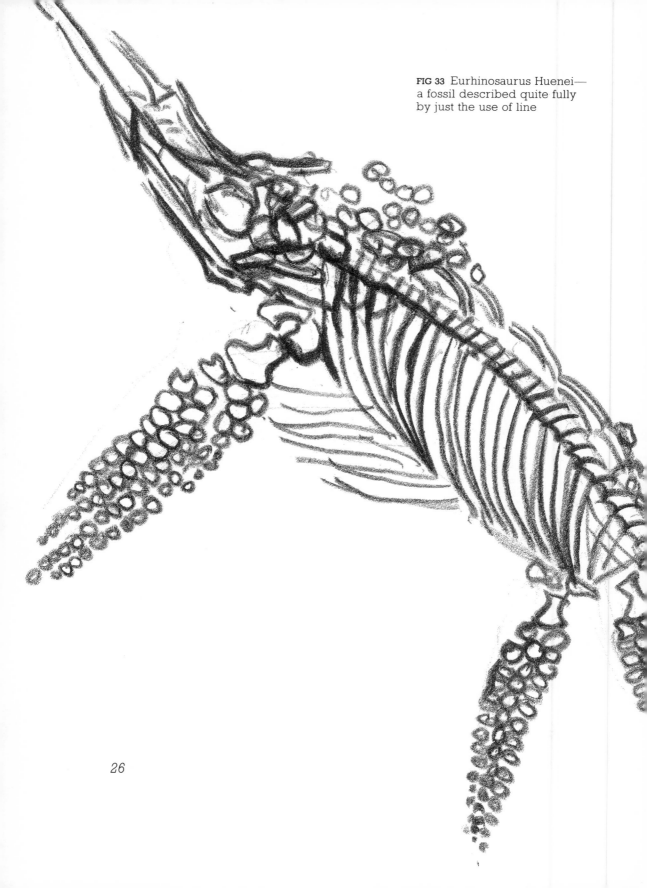

FIG 33 Eurhinosaurus Huenei— a fossil described quite fully by just the use of line

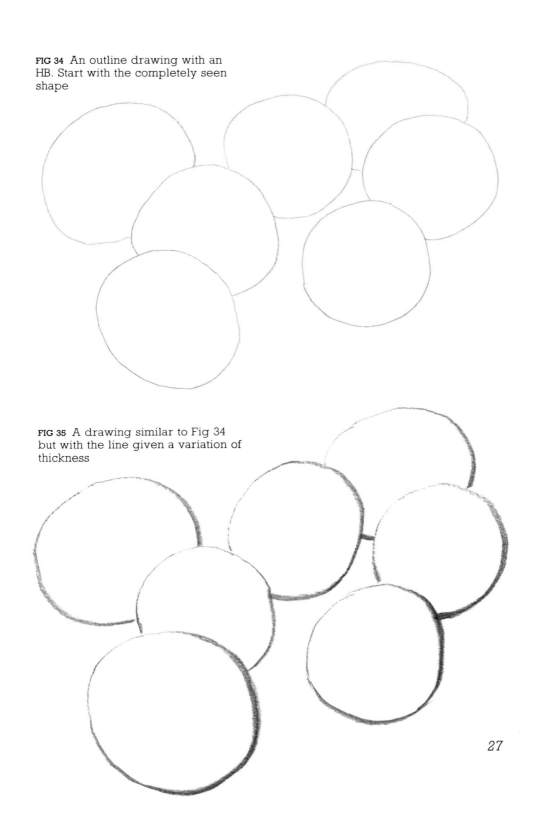

FIG 34 An outline drawing with an HB. Start with the completely seen shape

FIG 35 A drawing similar to Fig 34 but with the line given a variation of thickness

27

line when pressed lightly (Fig 36). This will no doubt happen without you noticing it, as you concentrate on the subject.

It is also very helpful practice to try making a line drawing without taking your pencil off the paper (Fig 37). Wonderful for concentration, it will make you think particularly hard, and you will find yourself holding your breath!

Good drawing is sometimes assumed to be only possible when considerable time is spent. Though this is true for some types of drawing, in others speed is paramount. Moving objects and changing circumstances do not wait for the artist. And although for the experienced artist, the quick, dashed-off image seems to come so easily, for the newcomer the quick summing up, the quick judgements of proportion, direction and shape, can be far from simple.

But when beginning, a marvellous way to practise is to attempt very quick two or three minute drawings. It will quickly clarify what is important and what can be left out, and some may capture a quality which would have been lost in a more lengthy drawing (Figs 38 to 41).

The need of making marks quickly can extend into dots and dashes. A sort of short-hand will result, which, when not abused, can add to the descriptive range (Figs 42 to 45). These dots and lines, when made with a graphite stick, can become so thick that they begin to leave the realms of line as such and become areas of tone, pale to dark patches which will eventually make up a picture (Fig 46).

FIG 36 A yucca plant drawn delicately with just line. One main front leaf was drawn first, others were then drawn in relationship to it, gradually radiating outwards

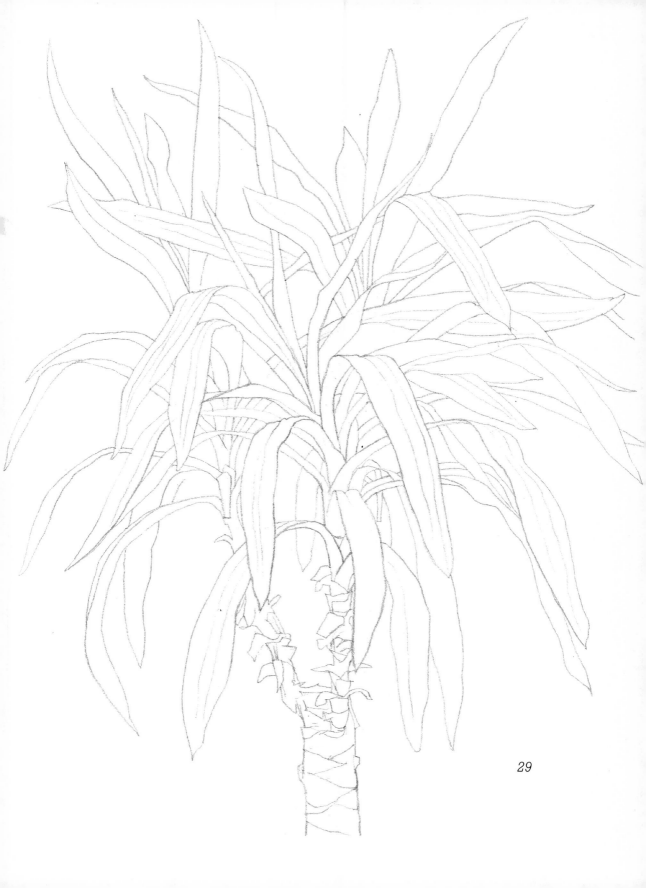

29

FIG 37 A hyacinth drawn with a single, continuous line. Some parts of the line have to retrace their path to deal with the complexity of the flower heads

FIG 38 Rapidly-made studies, taking less than 30 seconds—the movement of the boats precluded drawing for longer

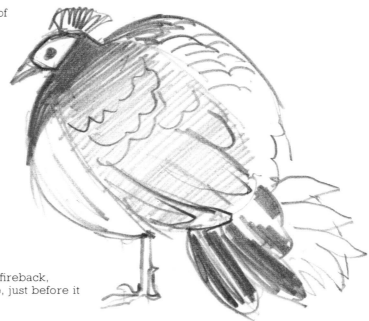

FIG 39 A Bornean crested fireback, drawn in its cage in a zoo, just before it strutted away

31

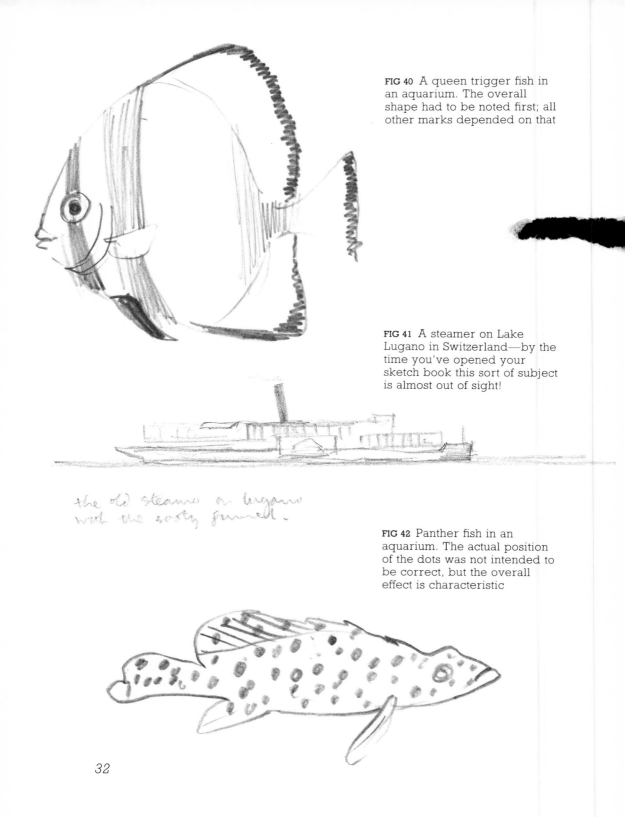

FIG 40 A queen trigger fish in an aquarium. The overall shape had to be noted first; all other marks depended on that

FIG 41 A steamer on Lake Lugano in Switzerland—by the time you've opened your sketch book this sort of subject is almost out of sight!

the old steamer on lugano with the sooty funnel.

FIG 42 Panther fish in an aquarium. The actual position of the dots was not intended to be correct, but the overall effect is characteristic

32

FIG 43 A field leading to some trees, the sort of quick statement which might be developed in another drawing later

FIG 44 Cats are marvellous models

33

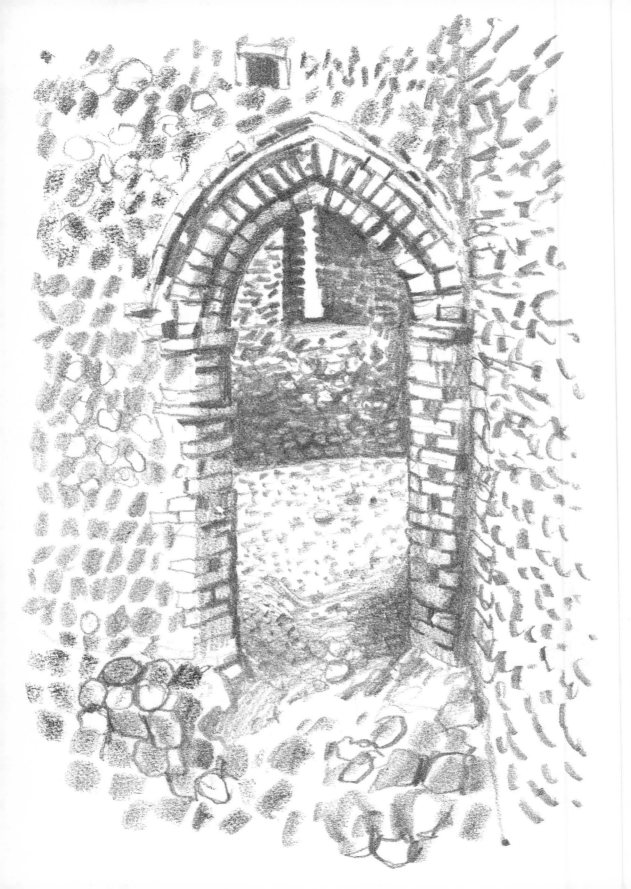

FIG 46 The simplest of landscapes using a wide graphite stick

FIG 45 The actual archway had to be carefully proportioned, so this is not a quick drawing, taking about one and a half hours. All its stones are reasonably accurate, but the flint walls were given their overall characteristic by briefly-made marks

CHAPTER 3

Shading

The assessment of tone is the most difficult part of art to grasp.

The white paper itself will be the palest tone the draughtsman can use. Shading with the softest, darkest pencil will produce the darkest tone. It is a value of lightness or darkness, whatever the colour (Fig 47).

If you are not certain how tone has such a dominating effect on what we see, look through two, or even three pairs of sunglasses simultaneously. This will cut down the quantity of light dramatically. Look at any group of objects: the light areas will quite naturally still appear to be the lightest tone, whilst in the darker areas, the tones will most probably merge and the individual nature of the shapes will have blended into one darker area (Fig 48). One could sum up the condition by saying the half-tones in the shadow are always subordinate to the shadow itself.

The eye is a very clever mechanism and with the knowledge of how things are made, the parts of an object are likely to be over clearly drawn. Differing colours within an object will also emphasise parts, yet when their actual tone is considered there may be little or no difference. When shading with the pencil one should try to maintain this tonal awareness.

Select a photograph, not coloured, which has some good pale areas, two or three middle grey areas and some dark patches, near black (Fig 49). Try making a copy of this using a 2B pencil. Create the shading by placing lines very close together, gently at first and then going over the areas that need to

FIG 47 A shading sample showing five grades of tone

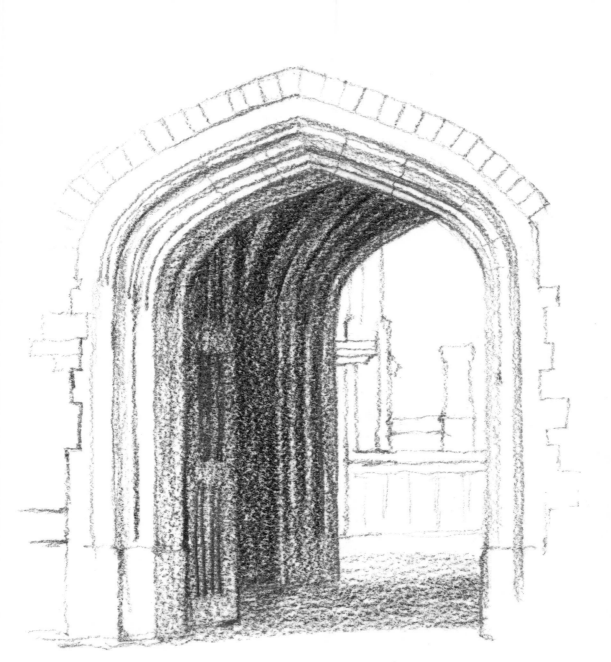

FIG 48 Henry VIII Gate at Windsor Castle showing the structure of the door and far arch still recognisable, but dark enough to maintain the fact that they were in shadow

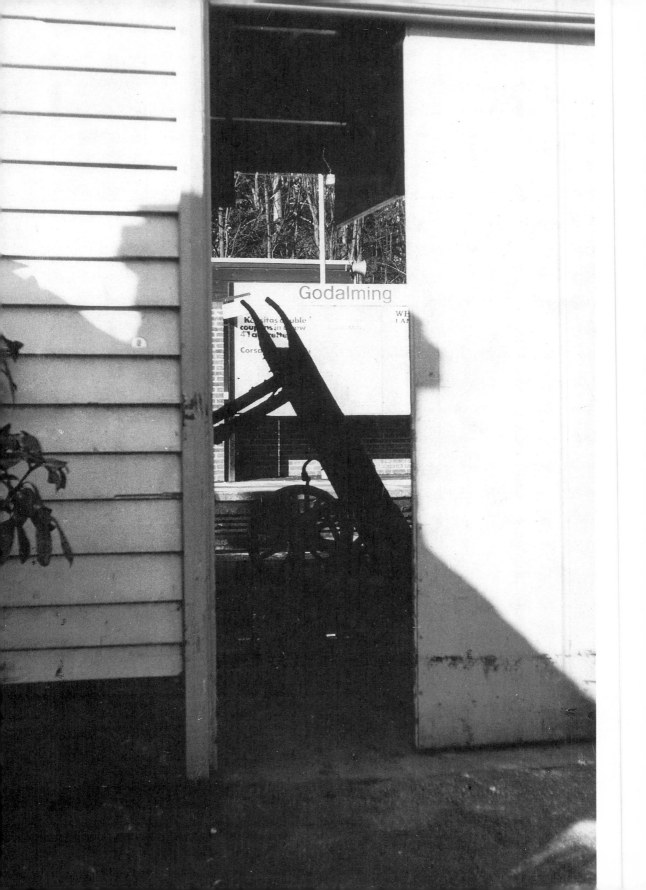

FIG 49 A photograph taken at Godalming Station showing clear tonal changes. Notice how the pale weatherboarding on the left and the door on the right change in tone where they are in and out of the light

FIG 50 Single lines of shading allow more control over where they start and stop; on the other hand the lines do not want to be over-precise as if drawn with a ruler

FIG 51 Scribble lines—in fact one line travelling backwards and forwards—are more likely to run out of control with dark ends and over large white spaces

be darker, again and again. Try to make single lines (Fig 50) (you will be more conscious of where they start and stop), rather than zig-zag or scribble lines which can produce a darkening of tone at the point of turn and distracting white spaces (Fig 51). By thinking of the picture rather like a map, it can help to do the whole thing upside down. In this way the shapes and tones will be given more importance than the actual subject (Fig 52). Don't spend more than an hour, and only when you have finished should you turn it round. Then don't fiddle with it, for it is most unlikely that you will improve your drawing. If you feel curious enough to attempt two versions, try the first from an upside down picture, and the second the right way up. I predict that the first will have a better overall unity.

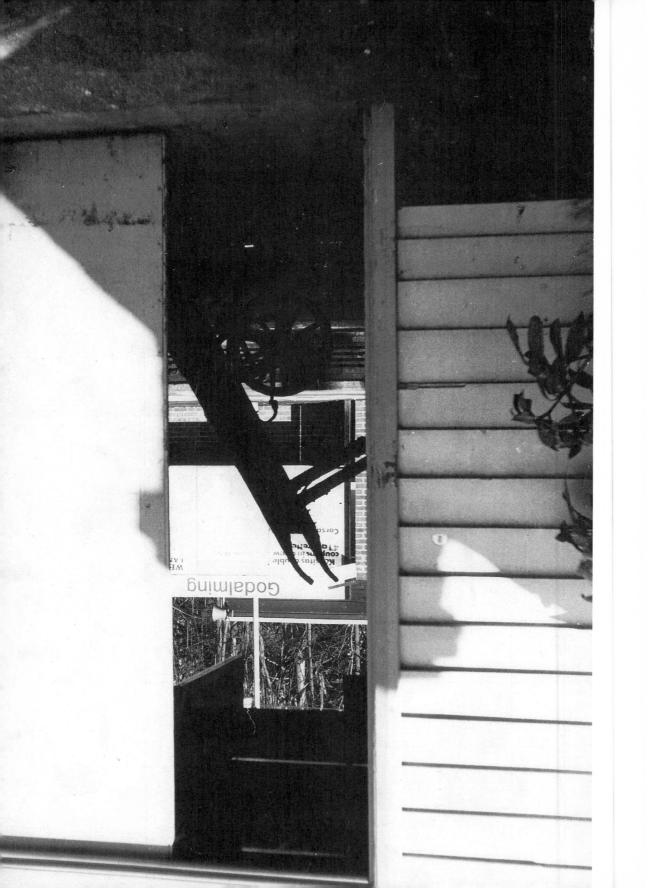

FIG 52 Fig 49 upside down

FIG 53 The area of a drawing showing simple division marks to aid copying

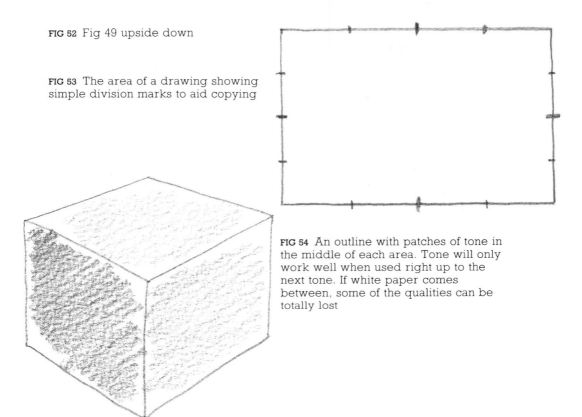

FIG 54 An outline with patches of tone in the middle of each area. Tone will only work well when used right up to the next tone. If white paper comes between, some of the qualities can be totally lost

When making copies of this sort, it can be helpful to think of divisions of the original (Fig 53). It is not difficult to imagine a division of half the picture, half that will give a quarter. These quarter divisions across and down the picture area can, if you wish, be marked at the edge of the original, and at the edge of your own drawing. They serve as a sort of grid or framework against which the shapes within the picture can be matched. This approach is far superior to making a tracing—for the tracing will do little to train your eye.

When copying a black and white photograph, the assessment of tone is not too difficult because the values are already there, but when working from actual observation this assessment is what makes the artist! For this reason I recommend only limited copying—the advantages, fine for a beginning, are really very short lived.

The most effective use of tone is achieved by using it from the very outset of a drawing. I would warn against drawing a heavy outline and filling it in with shading (Fig 54). This way of thinking is quite opposite to what is needed. The line defines the edge of a shape and in fact disappears where the shape actually turns away or vanishes. The contrast with the next shape or space produces this 'line'. Of course there is no actual line running round the edge of everything.

41

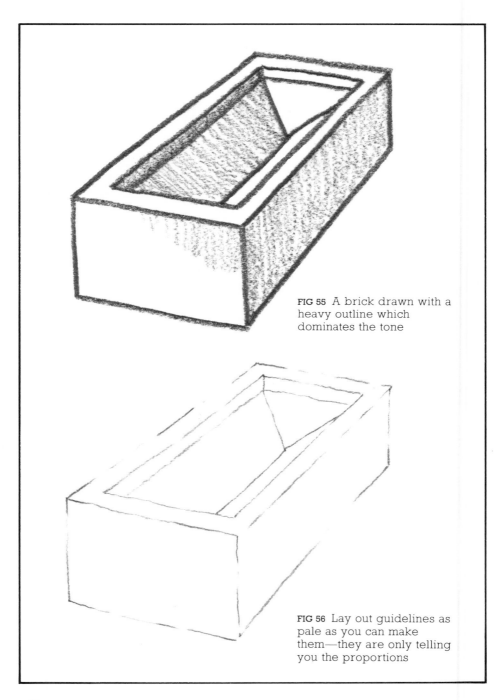

FIG 55 A brick drawn with a heavy outline which dominates the tone

FIG 56 Lay out guidelines as pale as you can make them—they are only telling you the proportions

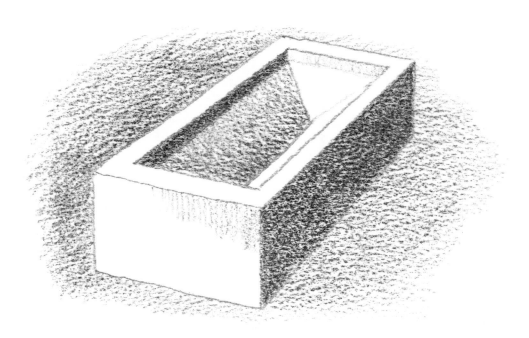

FIG 57 The tone, when developed fully, will dominate most of the drawing

Try drawing a brick with tone, one side of it may be dark, the other light. A dark line at the outside edge of the light side is therefore a sudden contradiction (Fig 55). It is much more likely that it is the background which, being darker than the light side, will make the contrast, showing up the edge.

So with the minimum of layout guidelines (Fig 56), try to shade right from the start of the drawing. Even if the patches are indecisive and pale, as you become more sure of their individual value and of their relationship with one another, it will be possible to consolidate the shape and to strengthen the dark areas until they are at the fullest darkness required (Fig 57).

But how dark is dark? The brilliance of light or the richness of a dark deep cave is far beyond the range of white paper and soft pencil. Therefore the drawing using tone made by shading must be a sort of translation.

The light, or white of the paper, must equal the lightest tone in nature and though the dark pencil may seem to get closer to the richest black in observation, it will not really match it (Fig 58). Another limitation must also be taken into account, that of the pencil itself. If in shading the graphite is loaded too heavily on to the paper, it can become shiny and the paper swamped. The paper surface can even be dented. This is sometimes difficult to anticipate, and by laying the shading lines at varying angles, called cross-hatching (Fig 59), the tone can be built up in gradual stages, and thus you will not unintentionally lose sight of the texture of the paper.

If this method is used too coarsely (Fig 60), the drawing can be spoilt, particularly when the scale of the drawing is almost smaller than the hatching. So the method of laying lines only slightly changed in direction (Fig 61), but still darkening the tone by successive layers, may be more sensitive to the scale of the drawing (Fig 62).

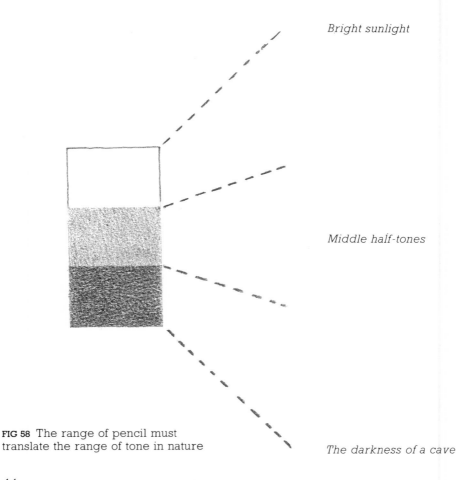

Bright sunlight

Middle half-tones

FIG 58 The range of pencil must translate the range of tone in nature

The darkness of a cave

44

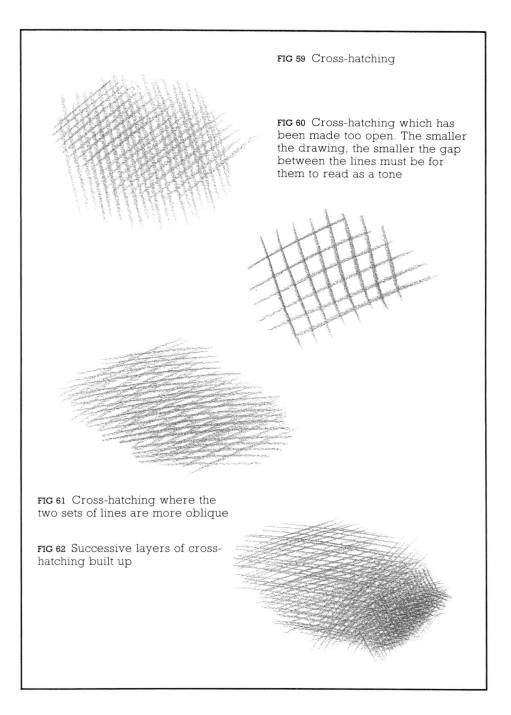

FIG 59 Cross-hatching

FIG 60 Cross-hatching which has been made too open. The smaller the drawing, the smaller the gap between the lines must be for them to read as a tone

FIG 61 Cross-hatching where the two sets of lines are more oblique

FIG 62 Successive layers of cross-hatching built up

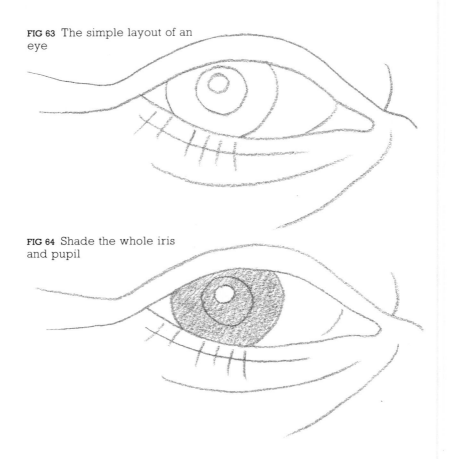

FIG 63 The simple layout of an eye

FIG 64 Shade the whole iris and pupil

Therefore, if you are looking at something described as black, your drawing will describe it as dark grey and everything paler will be drawn proportionately paler until any light, or sunshine or sparkle can only be white paper—that is, no drawing at all. This practice of leaving blank paper does need to be anticipated—not easy, but fun when it works.

Try drawing a simple eye. Lay out the proportion as in Fig 63. Shade round the spot of the 'shine' making the whole iris and pupil dark (Fig 64). Shade the pupil even darker (Fig 65). Ensure that you keep the 'shine' free of any shading. The white of the eye will never be really white, so shade this very gently all over (Fig 66). The surrounding eyelid can be made darker with some changes in tone (Fig 67). Thus everything will be shaded to some degree of grey except for the reflection in the eye, and only because of this preservation of white paper, contrasting with the greys elsewhere, will the sparkle look convincing.

46

FIG 65 Make the pupil even darker

FIG 66 Shade the 'white' of the eye—a little darker in the corner

FIG 67 Shade the area round the eye, slightly darker on the eyelids. The sparkle or reflected light in the eye will now be the most convincing

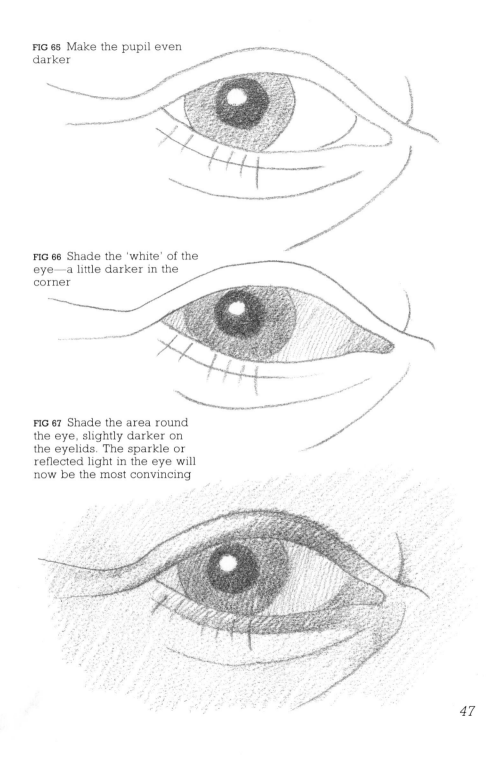

47

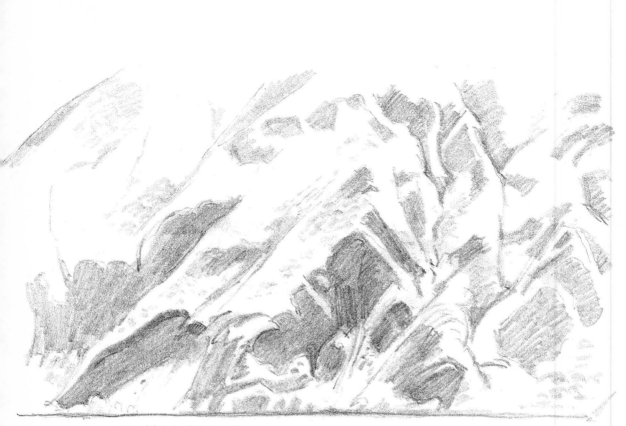

FIG 68 Mainly flat shading—a
sketchbook study of mountains coming
down to a lake

In Fig 68 the areas are generally flatly shaded, that is in one area the pencil delivers an even tone, though by giving a differing weight to neighbouring patches, a degree of modelling is achieved. Much variety and contrast can be created by this simple process.

Try to choose simple subjects which suit this approach. Cliffs and rocks can be good as they have flat facets (Fig 69), or a far, mountainous landscape (Fig 70). If you choose a building, ignore any brick, stone or tile texture (Fig 71).

This 'selection' is a constant part of pencil drawing, and your ability to choose will imbue the image that you make with a power and strength. I am avoiding the word 'clarity' here because the eye and brain will be aware of much more information than you need to make a successful drawing, so resist the temptation to 'improve'—to make little parts more detailed. Think of it like a menu in a restaurant. Few of us would actually eat every dish listed, but choose a selection of personal preferences to produce an overall balanced meal. Just so in drawing.

48

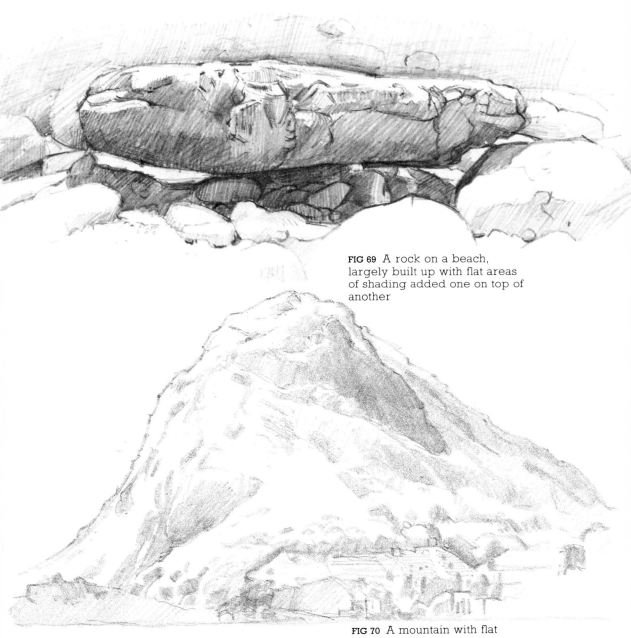

FIG 69 A rock on a beach, largely built up with flat areas of shading added one on top of another

FIG 70 A mountain with flat shading applied to all areas which were in shadow

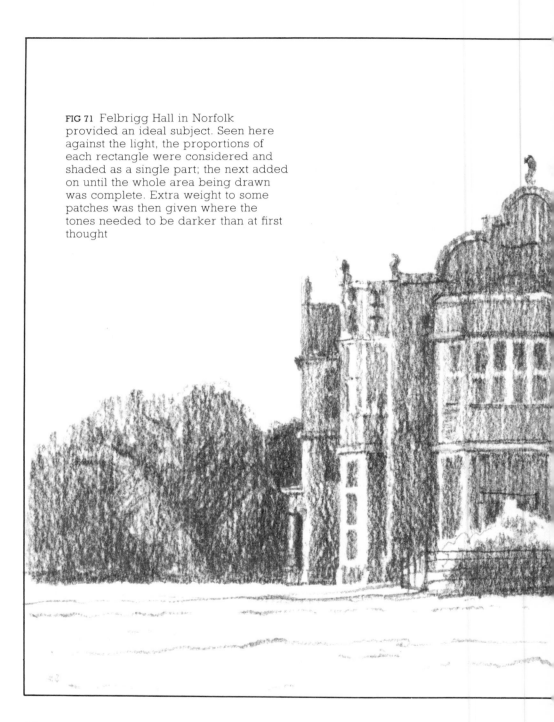

FIG 71 Felbrigg Hall in Norfolk provided an ideal subject. Seen here against the light, the proportions of each rectangle were considered and shaded as a single part; the next added on until the whole area being drawn was complete. Extra weight to some patches was then given where the tones needed to be darker than at first thought

CHAPTER 4

Solids

There does seem to be a bit of a knack about making a pale tone become gradually darker when crossing a curved form (Fig 72).

It seems simple enough to shade one area in a pale gentle way and to shade another area strongly. But it does need concentration and care to make one merge into the other without unwanted jerks of tonal change.

A simple, cylindrical object like a plain-coloured mug is an ideal starting point. Lit from one side only, try making a drawing of the tonal change from light to dark. The best sequence will be to lightly indicate the proportions and decide on the lightest area. The rest should be gently shaded all over (Fig 73). Then where the tone is seen to become darker, shade over the whole of this area again (Fig 74). Progress across the form reworking and reworking the shading so that it becomes darker and darker, but keeping the softness of the change the most important aim (Fig 75). The interior of the mug will require the same treatment, except the tonal change will be reversed, i.e. the interior side nearest to the spotlight will be in more shadow and therefore darker than the side facing the light.

Now this drawing will appear rather isolated on the sheet of paper. The object will have stood on a table of some sort and the light will have created a shadow cast by the cylinder. Try a second drawing with the mug standing on a surface as near to its own tone as possible. This time shade the object and the shadow as one (Fig 76). Follow the same procedure as before, gradually making the pale areas become darker, but still involving the shadow at every stage (Figs 77 and 78). Notice that the edge of the shadow is not likely to be crisp all round its edge. If a spot-light or table lamp is used, it is likely to have a diffused edge, particularly the shadow furthest from the object. Different objects in different locations will vary enormously of course, and reflected light will add a further element to be considered, but the principle remains the same. Notice how the brick drawn earlier, has more weight with its shadow included (Fig 79).

The pencil shading may perchance over run. Do not despair and call it wrong. There is a lot to be said for the freedom the mark makes and for edges

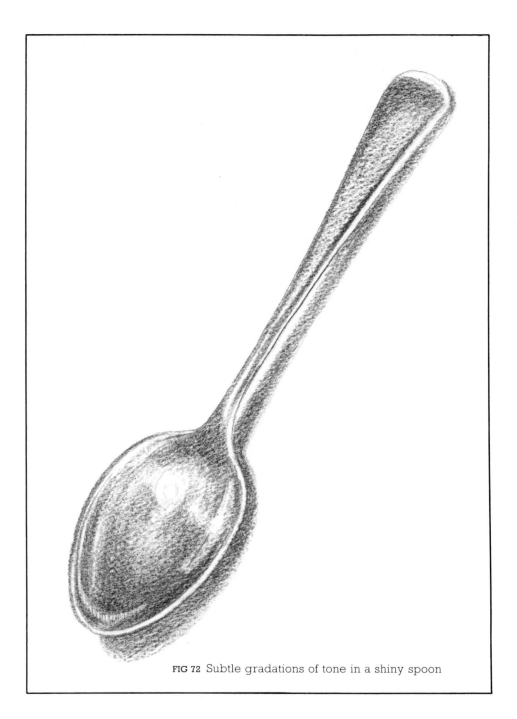

FIG 72 Subtle gradations of tone in a shiny spoon

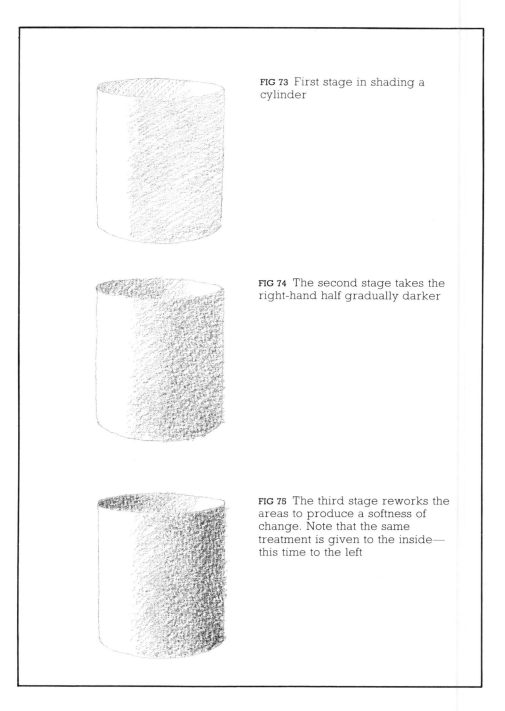

FIG 73 First stage in shading a cylinder

FIG 74 The second stage takes the right-hand half gradually darker

FIG 75 The third stage reworks the areas to produce a softness of change. Note that the same treatment is given to the inside— this time to the left

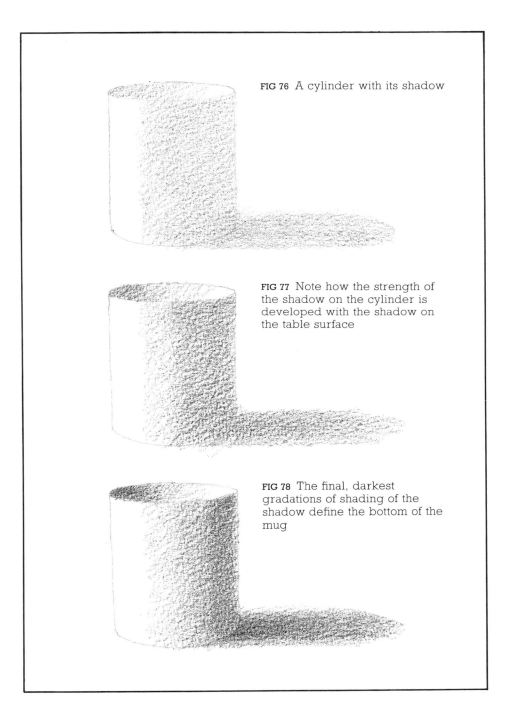

FIG 76 A cylinder with its shadow

FIG 77 Note how the strength of the shadow on the cylinder is developed with the shadow on the table surface

FIG 78 The final, darkest gradations of shading of the shadow define the bottom of the mug

FIG 79 The brick first seen in Fig 57 now has its shadow

which are not over-precise and harsh (Fig 80).

There are many qualities in drawing; some to the newcomer may seem contradictory. Detail does not always help reality, while coarseness and irregularity can sometimes add to it. Half close your eyes to see the apparent effect of a subject, and view your drawing in the same way. Or put your drawing on a board and view it from the opposite side of the room at dusk or in low light. You will find that the apparent reality of the drawing will be increased. Turn on a bright light and all the drawing marks will come to the fore again. The drawing can never be the object, it can only suggest some comments about it. It must be a translation, just as the words you are reading have to be translated. The word 'bowl' only sets up the idea of a bowl. The drawing of the bowl is an illusion and remains drawn marks (Fig 81). If you strive for too perfect an edge, or too clinical an image with not a mark or area of shading out of place, one may find that although the image is complete, it does not look convincing.

Rulers are not the stuff of drawing. Let the hand control the line; once down let it stay. Plan to do another drawing when the first is finished. Most accept that the musician must practise; few realise that the artist and craftsman has to do so too.

56

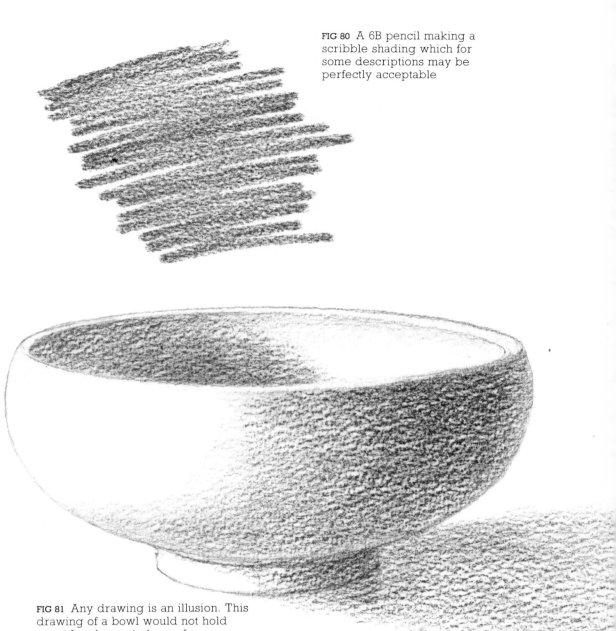

FIG 80 A 6B pencil making a scribble shading which for some descriptions may be perfectly acceptable

FIG 81 Any drawing is an illusion. This drawing of a bowl would not hold soup! It only reminds us of our previous experience of a bowl and what purpose it could fulfill

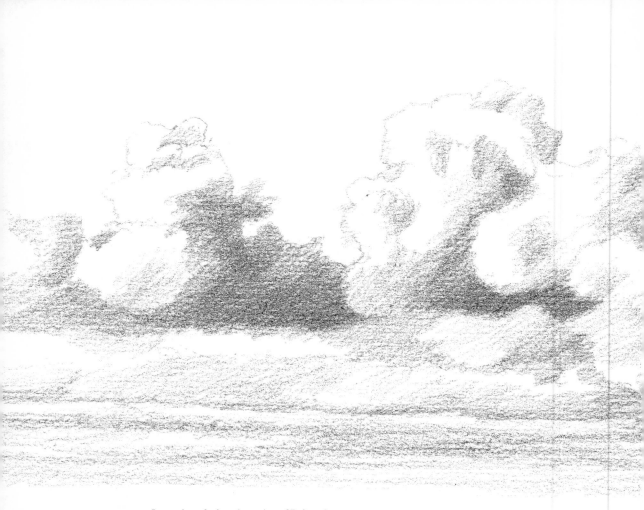

FIG 82 A study of clouds using 2B for the shading

Shading and tone can be great fun when drawing big voluminous forms like clouds (Fig 82), or an old, gnarled tree (Fig 83), because one does not have to be perfectly accurate. Shade the areas and make the changes and gradations according to your thoughts of light and dark, and while working stand back frequently to observe the effect you have achieved. Objects forming a still life may provide some of the best chances for drawing experience. An arrangement of loaves of bread will last well, so long as you're not tempted to eat them (Fig 84). Some of my pupils once did just that, leaving the outside crust looking untouched, while all the soft, fresh bread inside had been removed—but I could not guarantee such success a second time!

As textures become more important, so too will the sequence in drawing. As a general rule, do not put in details first. Aim at the overall shape of things, the main tonal areas and only then sub-divide into smaller parts and shapes.

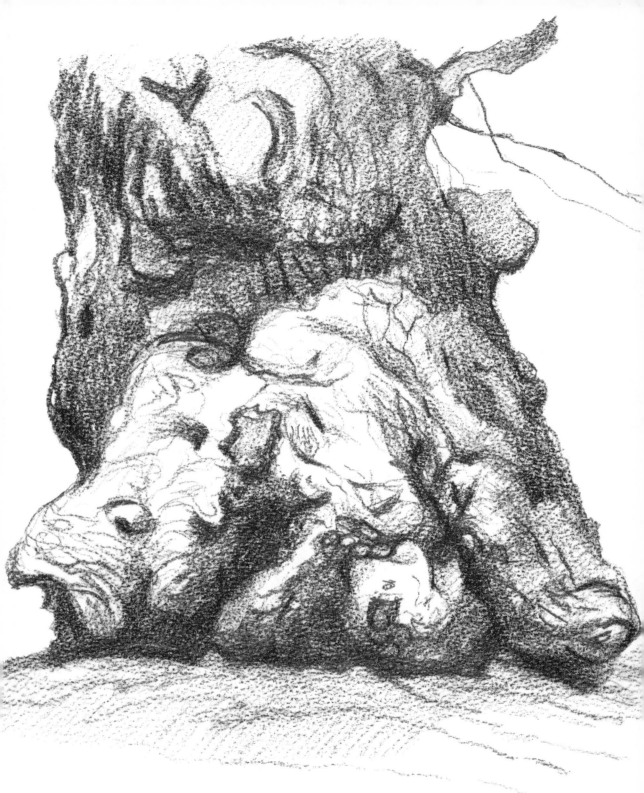

FIG 83 8B used for the drawing of a gnarled oak in
Windsor Great Park

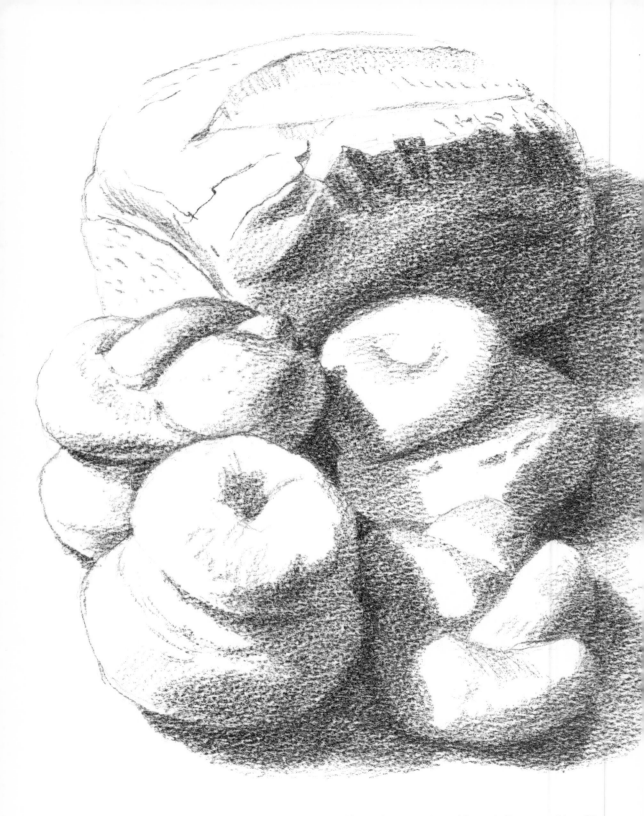

FIG 84 An arrangement—called a still life—of a selection of bread. Drawn with a 6B

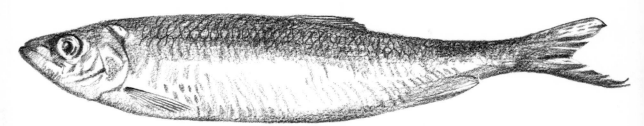

FIG 85 A mackerel drawn with an 8B where the areas of 'shine' not touched with the pencil are vital to the overall range of tone

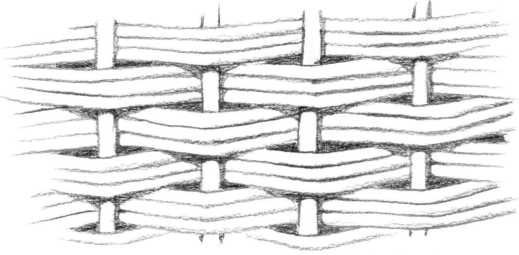

FIG 86 Part of a basket where the shadows show up the formation of the structure

The mackerel in Fig 85 is a good example. The overall shape came first, a faint line with some attention to the head parts and the size and position of the eye. Then I shaded the whole of the upper half of the body and the lower margin. Maintaining the 'shine', I introduced lines for the wrinkly skin and shaded areas shining less in the lower part of the body and the head. Last of all came the lines of the scales on the upper half of the body—on top of the general tone. But what might be described as detail can be difficult to define.

In the basket in Fig 86, the system of lines was laid out first and then shadows added to help the alternate projection and recession of the weave.

FIG 87 The first of two related drawings of a zebra made at London Zoo, in which the tone of the stripes has been ignored

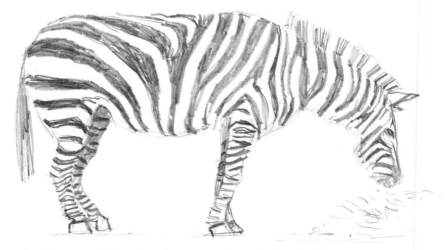

FIG 88 In this second drawing, the stripes were given priority right from the beginning

This sequence and decision on priorities can shift the aim from translating nature's tone to clarifying the shapes. For example, a striped zebra could be drawn ignoring the stripes and only drawing the shape of the animal (Fig 87). However, so strong is the pattern that I found it much simpler in the second drawing to shade the stripes one by one and relate them to the whole form, using only the slightest boundary line (Fig 88).

Fig 89 shows how the shape of the langoustine is assisted by the shadow on the far side of the body towards the tail—a little shading on the segments of the tail and the shadows cast from one leg on another.

62

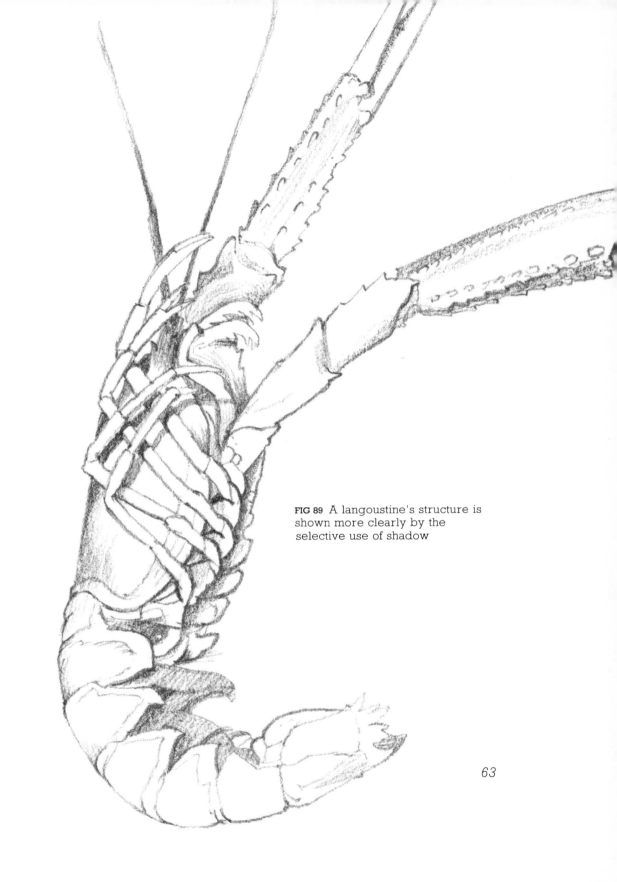

FIG 89 A langoustine's structure is shown more clearly by the selective use of shadow

FIG 90 A rolled paper stick for smudging or softening pencil marks

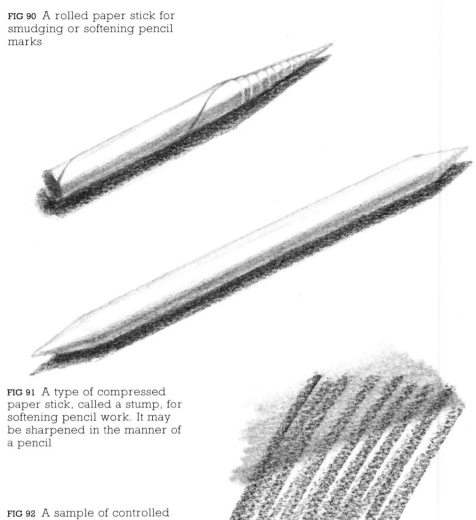

FIG 91 A type of compressed paper stick, called a stump, for softening pencil work. It may be sharpened in the manner of a pencil

FIG 92 A sample of controlled smudging

Smudging shading with a finger to get a soft grey has never been to my liking because of its imprecise control. But to smudge with a rolled paper stick, called a 'tortillon' by some manufacturers (Fig 90), or a 'stump' (Fig 91)—a sort of compressed paper pencil—is quite a different matter. When used with a very soft pencil the quality of the gentle greys is excellent for some subjects (Fig 92). For the tennis ball in Fig 93 it seems ideal for the soft, downy texture, but for the wooden plane—a heavy, hard object—it does not seem so appropriate (Fig 94).

64

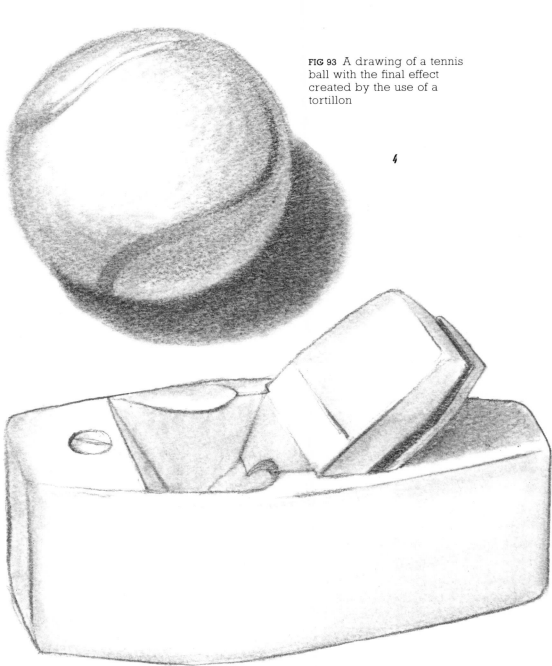

FIG 93 A drawing of a tennis ball with the final effect created by the use of a tortillon

FIG 94 A drawing given similar treatment to that in Fig 93, but the use of it for a 'hard' surfaced object is questionable

CHAPTER 5

Perspective

Most people will have heard the saying 'There is no such thing as a cheap object, only a less expensive one'. It would be equally right, I feel, to say that there is no such thing as a bad drawing, only a less successful one.

One of the things which disturbs the eye is an object which looks crooked. Like a wilting flower, it is immediately noticeable that something is wrong.

Some critics are quite correct when they suggest that getting perspective right is not the total answer to making successful drawings, but it is quite revealing, when looking at retrospective exhibitions, to see how many of the great names in twentieth-century art show in their early works a remarkable ability in academic drawing and a sure grasp of perspective. It does not mean ruling straight lines, but understanding the relationship of shapes, one with the other. Of course an object does not change, but as we move about, what we see of it does.

As we stand behind a person we do not see the eyes (Fig 95); this simple and very obvious fact is not always immediately grasped by the aspiring artist, who is often tempted to draw parts of the figure which cannot actually be seen.

In a simple landscape we can observe three trees, the closest one is the largest in the drawing, the middle one smaller, and the furthest tree the smallest. Their relationship shows perspective for in reality all are of roughly the same height, but as they stand further away they appear to diminish in size (Fig 96). Though the buildings in Fig 97 vary in size it is probable that the church with the spire, though small in the drawing, would in fact dwarf all the other buildings seen. This happens to everything we see, only when things are in a room the change in size is far less noticeable. Nevertheless there is a change.

I expect you have a rectangular table somewhere at home. Try the following experiment. Sit or kneel in the middle of the longest side, put your elbows on the table surface and cup your chin in your hands. You know that the edge of the table just in front of you is straight. So is the far side of the table—straight and horizontal. Look straight ahead and find a spot on the wall which you could describe by just that term—straight ahead. Now without

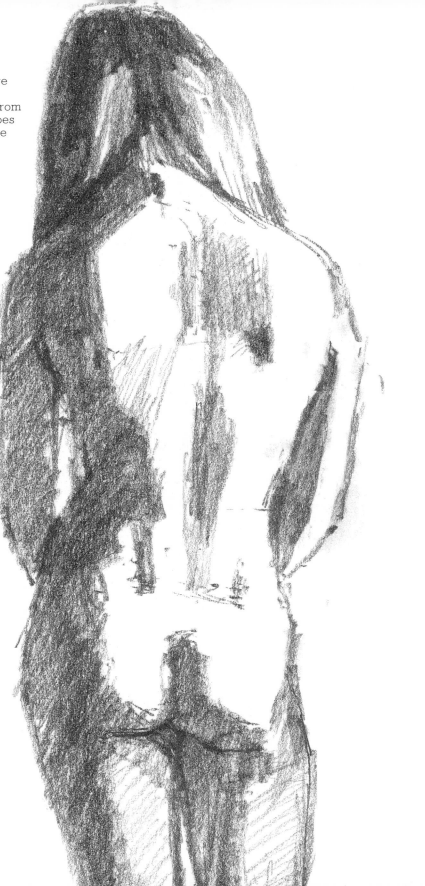

FIG 95 The eyes are not seen when a figure is viewed from the back, but it does not mean there are none!

FIG 96 Three trees of roughly the same height diminishing in size as they stand further away because of the effect of perspective

FIG 97 A view towards St Peter Mancroft Church in Norwich. Though small in the drawing, it is immediately understood that in reality it would stand above all other buildings in the view

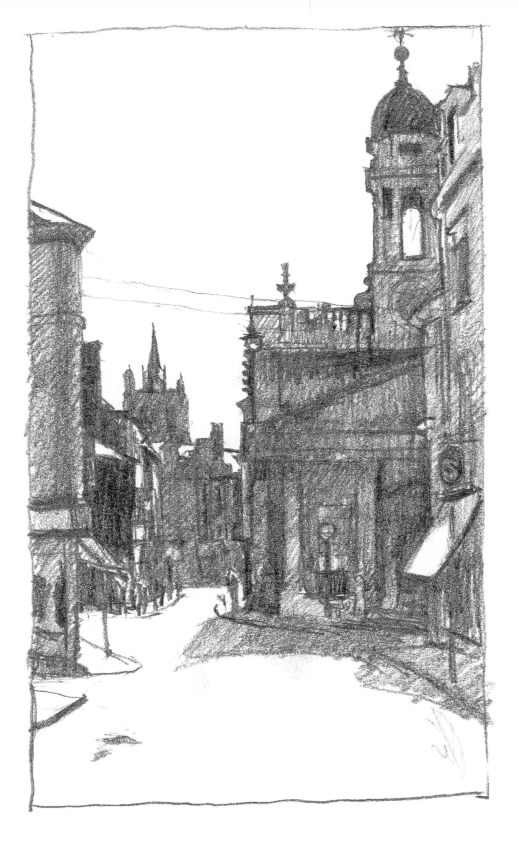

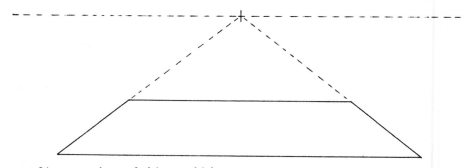

FIG 98 Lines or edges of objects which are made parallel will appear to converge to a point at infinity—straight ahead

moving your head, move your eyes to look at the right-hand side of the table, the edge. It will appear to rise as it travels away and if you follow its direction it will arrive at the 'straight ahead' spot on the wall. Let your eyes move to the left edge of the table—it too will travel towards the spot on the wall straight ahead of you. This is the table which you know is rectangular, and which has the right and left sides (as you are sitting) actually parallel to one another, but appearing as if they converge and would meet at this point on the wall ahead. This is one aspect of perspective (Fig 98). Your table has not gone lopsided, but the appearance is not what you know the actual shape of the table to be.

The spot is called a vanishing point and will lie on your horizon straight ahead of you. All regular objects will have their known shape changed in appearance in this way, but since objects lie at various angles to the observer and to one another, their vanishing points may well lie far out to left or right (Fig 99). When you start looking for it you will begin to notice how subtle these lines and directions can be. The lines which like the table edges lie below your eye level, will rise as they move away from you towards their vanishing point on your horizon, while those above eye level will appear to drop towards your horizon (Fig 100).

Try taking a tracing of Fig 101. You will notice the directions of the lines very quickly.

The following drawings (Figs 102 to 107) illustrate a variety of these directions and becoming aware of these will help your drawing enormously. Not all follow edges, but form a helpful imaginary framework to help you lay out what you see. When you are more familiar with drawing your judgement will take these directions into account quite naturally, but remember that seeing a line or proportion in an existing drawing is one thing—getting it right in your own drawing requires practice and experiment from observation.

FIG 99 An object with a rectangular form will have vanishing points lying to the left and right

horizon

FIG 100 Lines appearing to travel towards your horizon, when below your eye level will rise to the horizon, while those above your eye level will descend to the horizon

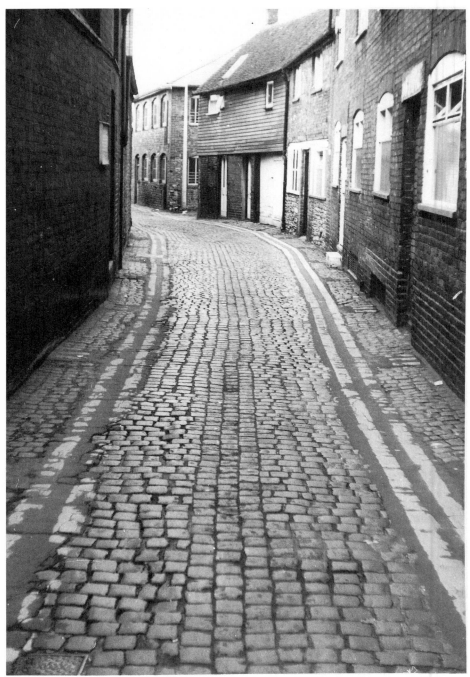

FIG 101 This photograph of a lane with granite sets and similar elements in the buildings, shows immediately the strong perspective directions all the parts take

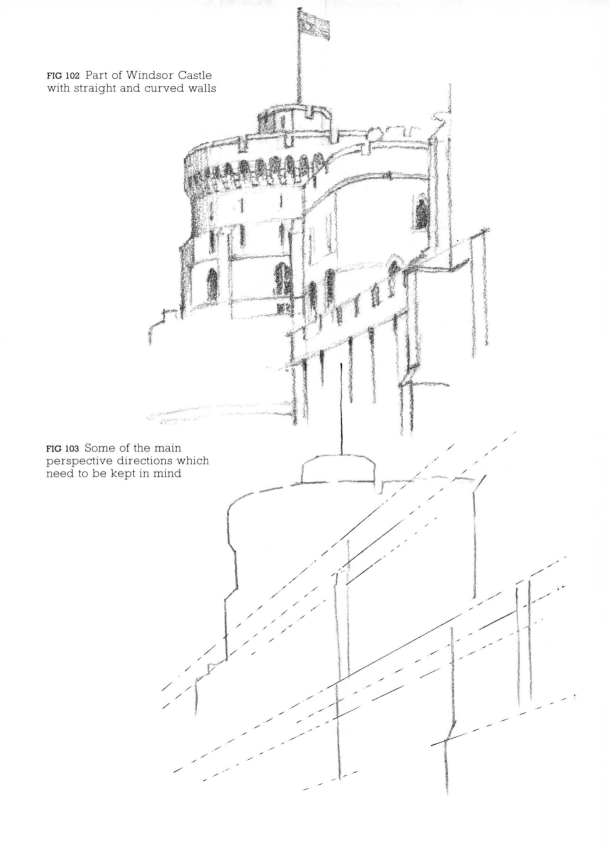

FIG 102 Part of Windsor Castle
with straight and curved walls

FIG 103 Some of the main
perspective directions which
need to be kept in mind

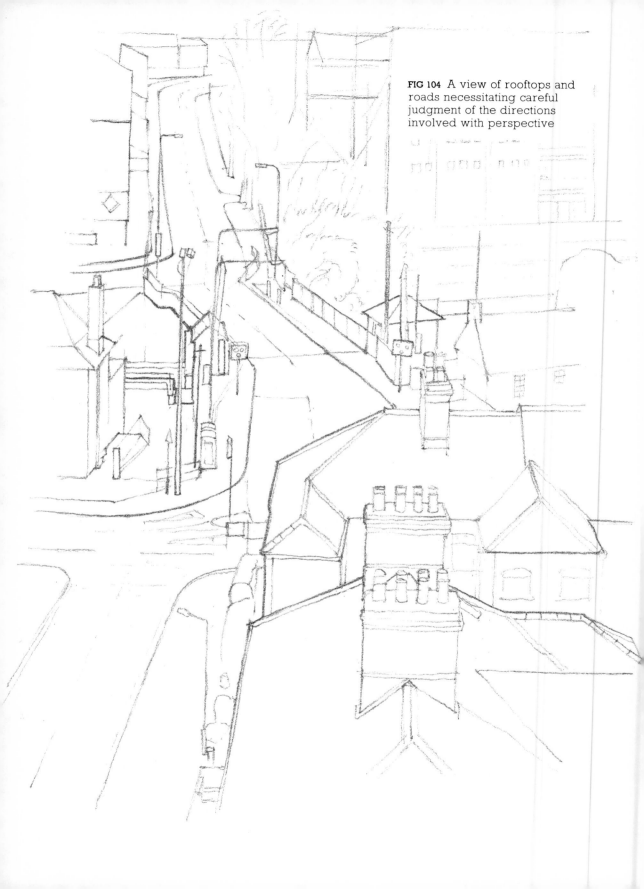

FIG 104 A view of rooftops and roads necessitating careful judgment of the directions involved with perspective

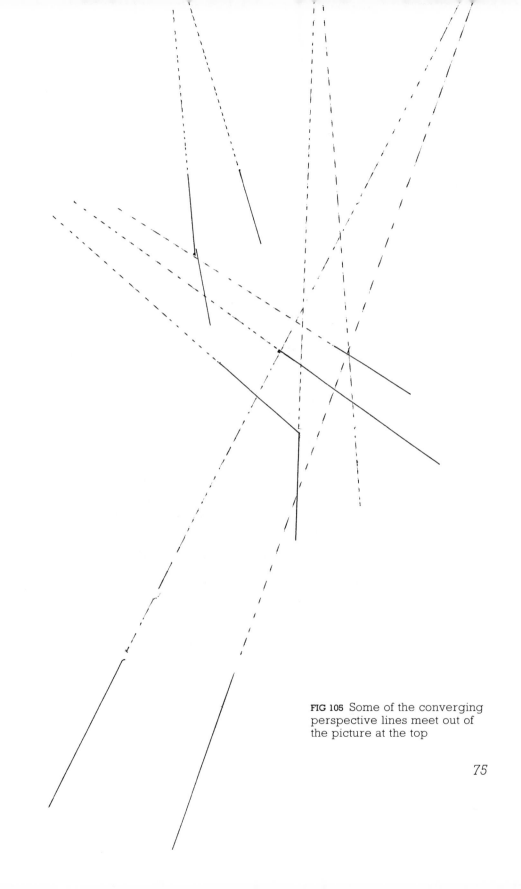

FIG 105 Some of the converging
perspective lines meet out of
the picture at the top

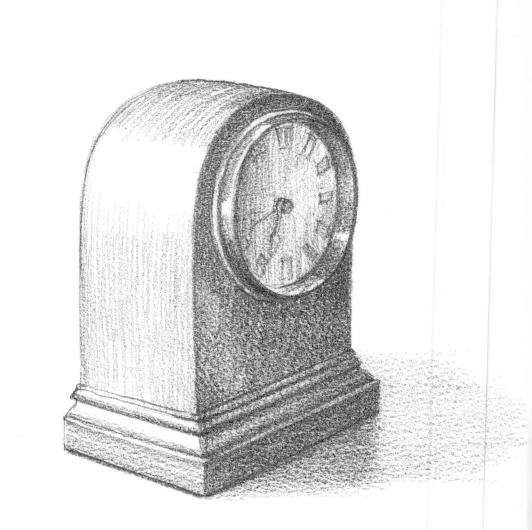

FIG 106 A clock in a wooden case

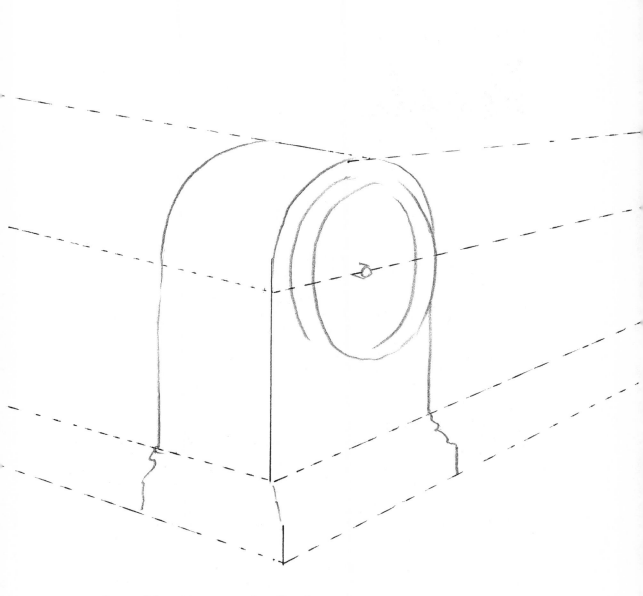

FIG 107 Some of the main perspective directions

CHAPTER 6

People

Drawing from a person—figure drawing or life drawing as it is termed—is likely to make the most demands on the artist but offer some of the greatest rewards.

While the appearance of a tree can be varied without any great dismay, it is likely that the slightest inaccuracy in a portrait will be recognised by the artist and, what can be even more daunting, by the sitter. Most concern will be for likeness, yet this is not a commodity which can be added to an otherwise satisfactory shape. The likeness is the shape and will only trap that elusive character when all the parts and areas fit together to make a whole. So it is the shapes and relationship of proportions which the drawing must seek out. No easy task and one which will require practice—but then what worthwhile achievement does not.

Fig 108 shows a line drawing of a head. Do not fall into the classic mistake of giving the top of the head too small a dimension. It is quite likely that in most views the distance from the chin to the centre of the eye will equal the distance from the centre of the eye to the top of the head, as happens in this illustration.

Drawing slightly from one side—a three-quarter view—will reveal the different sizes of similar parts (Fig 109). The whole figure requires comparisons to be made between the length of the body and the length of the legs (Fig 110). When the legs of a seated person are viewed coming towards the artist, it can be easy to misjudge their length. They are likely to be bigger than you first think.

With all these thoughts about shape, the pencil itself may seem to have been put into second place. Well, that's its strength. It is so undemanding that it will allow all necessary thoughts to be given to the complexities of the subject.

But as experience grows so the focus on the pencil can return for the modelling of the forms of the figure will add much. Delicate shading can be developed on a pale framework. Don't draw a heavy outline—you will only be telling yourself the shape at this stage. As the darker areas of tone are identified, rework and rework those parts- -taking care not to lose the clear paper describing the lightest parts of the figure (Fig 111). If shading is

FIG 108 A head showing the classic proportions: chin to eye equals eye to top of the head

FIG 109 The three-quarter view shows parts known to be roughly the same size, drawn to different sizes. Notice the size of the far lense compared with the near one

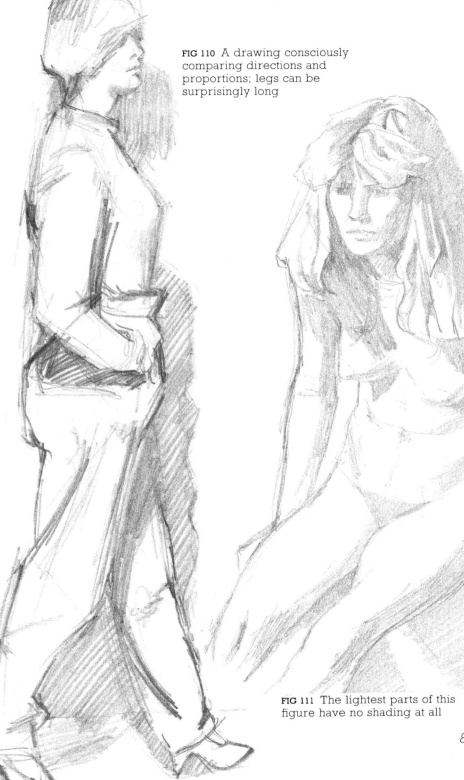

FIG 110 A drawing consciously comparing directions and proportions; legs can be surprisingly long

FIG 111 The lightest parts of this figure have no shading at all

FIG 112 The limbs of this child are 'woven' together. What starts as an outside boundary may end as an internal part of the drawing

FIG 113 Notice how the right leg of this figure becomes the back of the left leg

worked all over the figure it may become very grey and flat. The sparkle in the eye, practised in Chapter 3, can be very precious.

One of the particularly special characteristics of the human form is that it is made up of many linked and woven elements. This has the effect of a kind of plaiting (Figs 112 and 113). Thus one form twists into another, and any shading or outlines, though starting on the edge of the figure, are likely to move into the middle of a limb; likewise a shape may commence in the middle of the body but finally turn away over the edge of the boundary form (Fig 114). This structure is much easier to understand when drawing from a nude: one reason why this has been the classic subject of the artist for many centuries.

FIG 114 Most of the forms have to be
considered in relationship to others.
This drawing used black and white
wax pencils and was drawn on the matt
side of brown wrapping paper

FIG 115 The whole shape of curls is
more important than single hairs

85

FIG 116 The hair must be
drawn as a shape as part of
the head

As with all objects, the focus on detail is likely to be too sharp. Lines of
pencil representing strands of hair can look more like spaghetti, so
concentrate on the whole shape of a curl and the overall shape of the style,
with only a few wispy lines softening the edge (Figs 115 and 116).

For the whole figure, the emphasis should be given to the overall pose (Fig
117). In particular those areas in dark shadow should not be broken up with
highlights which destroy the role of the shadow in modelling the whole limb or
torso (Fig 118). If you err at all, subdue any highlights noticed in the shadows,
while any cast shadows such as those across floor and wall should be
developed and united with the figure itself (Fig 119). It is surprising how the
shading of a well observed shadow can do almost more to display the presence
of the figure than the figure itself. The drawing in Fig 120 has been left as a line
drawing with little or no shading, but its shadow is fully developed.

FIG 117 When drawing the whole figure, attention must be given to the relationship of all parts to the total structure—even if it means sacrificing some detail

88

FIG 118 When looking hard at a figure, do not over-state highlights within the shadow areas. They will not be as light as you think

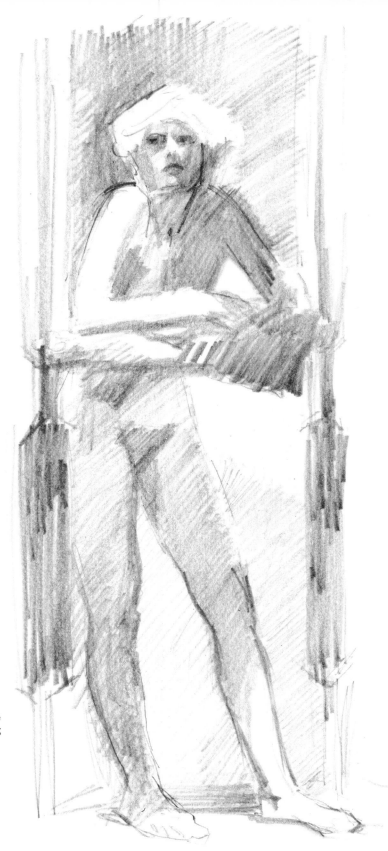

FIG 119 Do not be afraid to shade figure and shadow together; tonally they may frequently merge

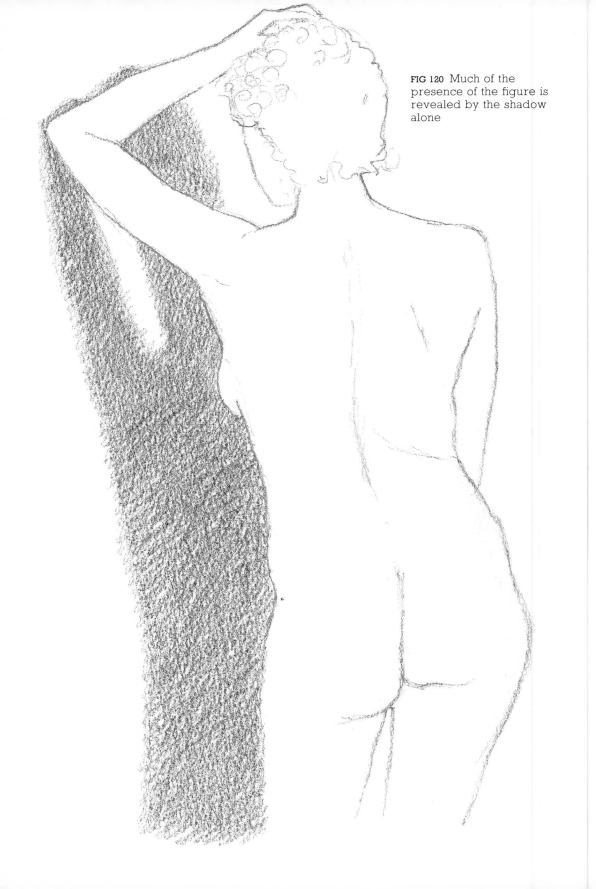

FIG 120 Much of the presence of the figure is revealed by the shadow alone

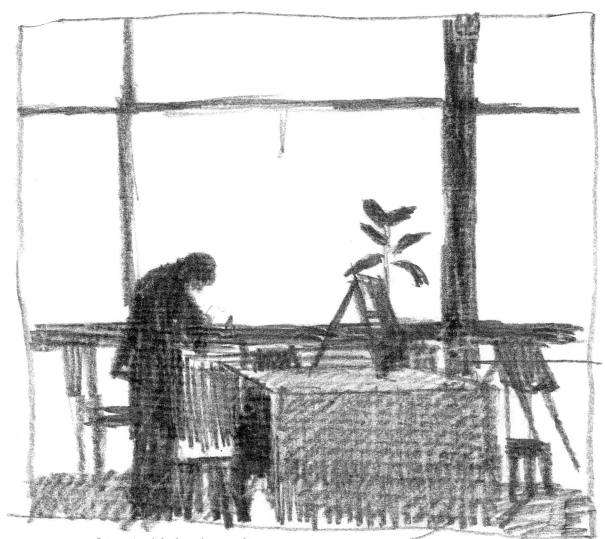

FIG 121 A very quick drawing made while the person was working and taking up a very characteristic stance. Likeness and recognition do not involve just the facial features

Curiously, the less you strive for a likeness, which of course involves the whole figure as well as the face, the more likely you are to achieve it as a development of all these other considerations. Fig 121 shows the figure as little more than just a shape, yet those who knew him would immediately find recognition.

CHAPTER 7

Trying new areas

An artist is rather like a reporter. There are some predictable occasions when work will take place—like an evening class or when on holiday (Fig 122)—but there are also unexpected happenings which are worthwhile capturing (Fig 123).

One advantage of the pencil and the drawing book is that they can be to hand all the time—indoors and out. Tiny drawing books are available—no bigger than a diary. For constant pocket use a stiff-backed bound book is best, but when moving into rather larger sizes there is quite a choice. Some have perforated pages which saves the book disintegrating if it becomes necessary to remove a drawing. Some are in pad form with a card back and stuck on one edge. I find this type the least useful for in turning over the sheet, it creases round the spine and can even become detached. The spiral bound type is for me by far the best. Permanent if you want to keep the book whole; easy to remove one sheet if the need arises and pages can be turned over to the back and lie totally flat. Two spring clips of a suitable size will hold down the two free corners.

Once some familiarity has been gained at home, try venturing further afield. Museums, for instance, can be the most marvellous places to work. With such rich and varied collections to choose from, few can fail to find something worth drawing (Fig 124). Do just take the precaution of asking permission, and then if possible choose the quietest part of the day.

However, large drawing books get a bit floppy, and a thin light drawing board with individual sheets clipped on probably works better. As the sheet on which one draws gets bigger, so location drawing gets decidedly difficult because the need to work on it in a more vertical position increases.

A small easel—collapsible for transportation—is quite good but they are not very firm on slippery floors. Permission would need to be sought for use in public buildings. Those easels which do provide a solid support are quite naturally heavier and therefore not so versatile for drawing (Fig 125).

It is important to keep the book or board straight to yourself and not slewed round at angles. The top edge of the paper should be parallel to the ground at

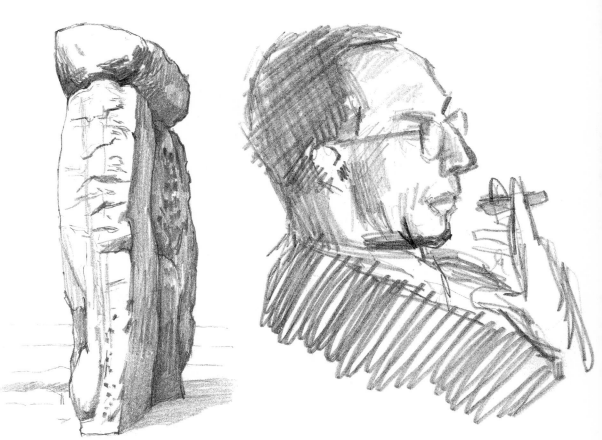

FIG 122 A study made at Stonehenge while on a touring holiday

FIG 123 A gentleman drawn while listening to after-dinner speakers. There was little possibility of a second chance

all times. If not, and your observation in drawing is not strong, all sorts of extra hazards can befall you!

A shoulder bag, many and varied in type and size, is ideal for outside use (Fig 126). It will hold spare drawing books, containers of fixative, as well as such things as the necessary, versatile plastic bag. It can be sat upon, or used to protect your drawings from the rain, or indeed to hold pencil sharpenings!

In the home a plastic tool box, sometimes sold as a fishing box, is useful. Quite inexpensive, they are light and provide a number of compartments and trays which can be opened out for access. They would be equally good for use in a car as a 'base' supply.

Every artist will decide what equipment suits them best, but it is worth remembering that in the end it is the smooth availability of materials which will dictate whether or not any drawing gets done at all!

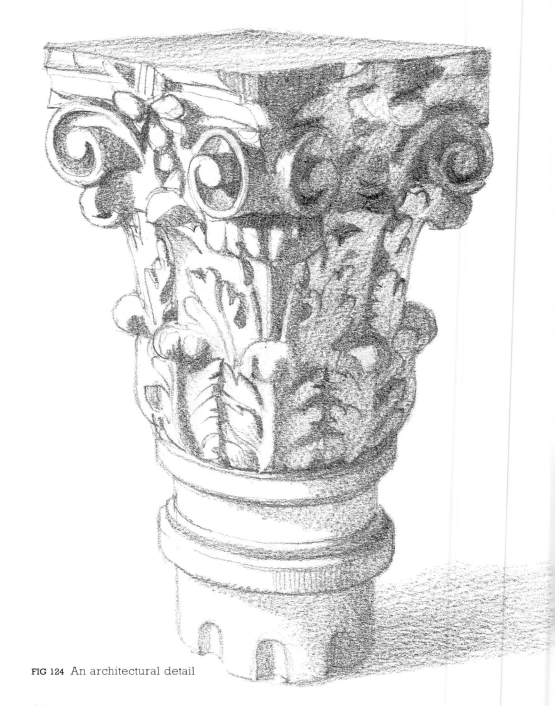

FIG 124 An architectural detail

94

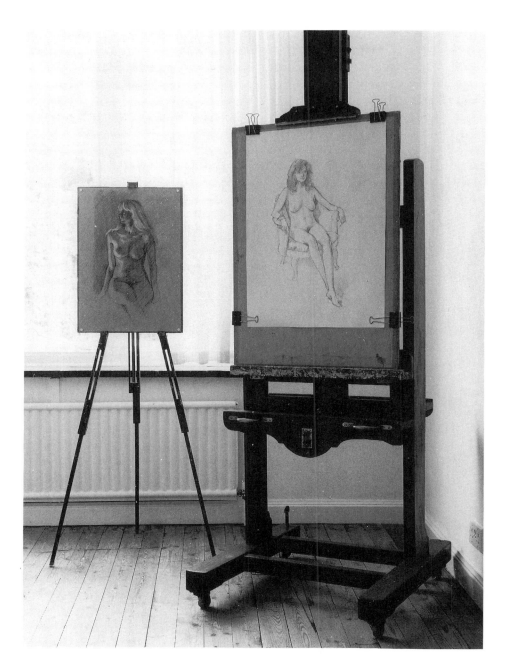

FIG 125 A sketching easel contrasting with a heavy large studio easel

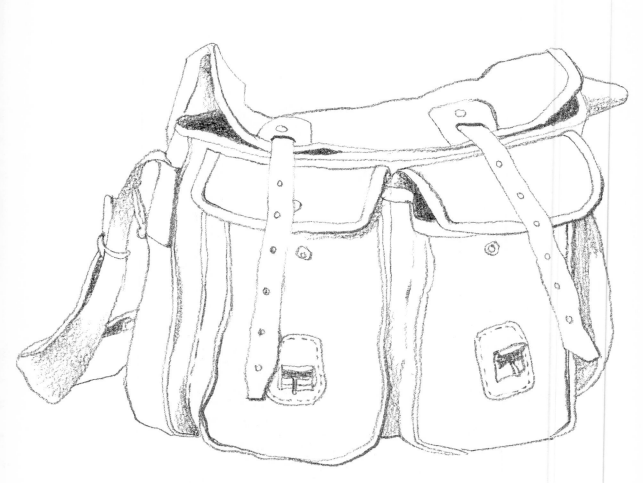

FIG 126 An ideal bag for carrying artists' materials

CHAPTER 8

Composing a Picture

The moment I make a rule or suggestion about composition, I could find myself contradicting it. Walk round any major art gallery or exhibition and the possibilities seem endless. Yet I will make some suggestions, if for no better reason than to provide a starting point for discussion. It will at least give you an idea of what should be considered.

Within the subject of this book colour plays little or no part. While in a simple landscape the sky might be a beautiful blue, there is little to excite in blank white paper. It is therefore very likely that an object or a cluster of varied objects will be central to our interest. If they are drawn too small on the sheet of paper, they will look very insignificant. Fig 127 shows the bread first seen in Fig 84. If on the other hand they are drawn too large, they may not even fit on the paper and just part of a loaf or bread roll might be completely unrecognisable as such (Fig 128).

Somewhere between the two extremes is what constitutes good composition. The best choice is to draw the main subject larger rather than smaller. Decide on the real centre of interest. To the first idea it is very likely you will be tempted to add more surroundings. Limit this where at all possible.

For example, flowers could well be the subject. They are placed in a vase. The vase stands on a table. The first idea of drawing the flowers can soon escalate into drawing the whole room! Now there is nothing wrong in drawing the room, but it will not be satisfactory if there is no particular reason behind your choice—and the original bunch of flowers will have become proportionately so small that it will be quite difficult to define them.

When possible let one side of the main subject be cut off by the picture edge. The classic example of this is the portrait where legs are not seen, the bottom of the picture intervening (Fig 129). A building might well be cut off to the right or left (Fig 130). This cutting off has a sort of 'locking' effect on the object, for if it is totally seen in the rectangle of the picture, the spaces all round may appear rather meaningless.

As with a person, a view of anything full flat on to the observer is likely to look just that—flat and not as interesting and revealing as an angled view. Often this is thought to be a much more complicated view to choose, but in fact

FIG 127 An over-small drawing within the picture area

FIG 128 Part of the subject in Fig 127 now possibly so enlarged as to be unrecognisable

it is quite the reverse. The variation in size of parts, the greater awareness of space, and the clearer description of form—how the object is made—all help the drawing.

A sash window is a good example. Flat on, like part of an architect's design, its structure can only be seen as two dimensional (Fig 131). Seen from one side, it reveals the thickness of the glazing bars, the outward placing of the upper unit to the bottom unit, the recession from the windowsill and from the wall itself (Fig 132); all this by line alone.

Composition is not just about nameable objects and how big they are, but about abstract shapes as well. A picture needs a group of shapes which by themselves seem to be satisfactory. It is difficult, I know to diassociate your feelings for the object and to think of shape and pattern alone (Fig 133).

Take this book for example. Turn it upside down, look at a page and consider the patches of printed words and shapes of the illustrations. This is a more abstract version of the example given in Chapter 3 (Figs 49 and 52). Because you cannot read the text it is easier to consider shape and tone alone.

Do this with one of your drawings. Move back across the room to view it. Upside down it will reveal its shapes, the darks and lights and the placing on the page.

Another compositional aid is to draw a line round the edge of your drawing. In other words, don't use the edge of the paper as the edge of the drawing, but rather create a drawn rectangle. This drawn edge is strangely helpful in making one aware of how the parts of the drawing relate to the final edge (Fig 134). Fig 135 also shows this. If drawn very faintly to begin with, its position

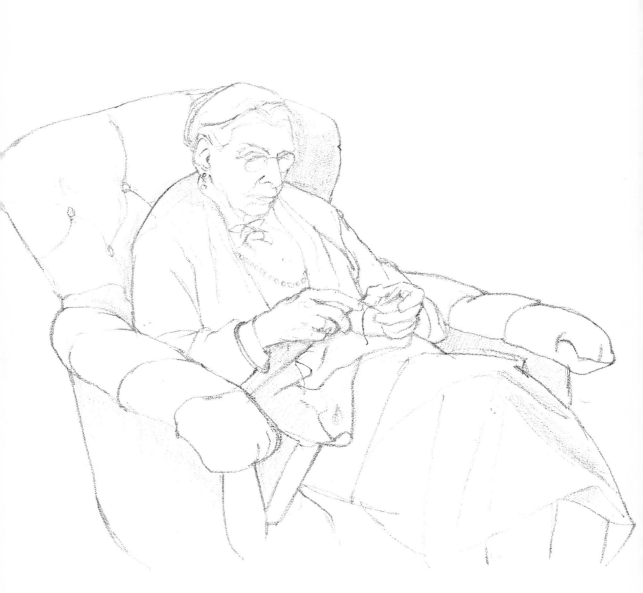

FIG 129 A composition cut off at the bottom edge

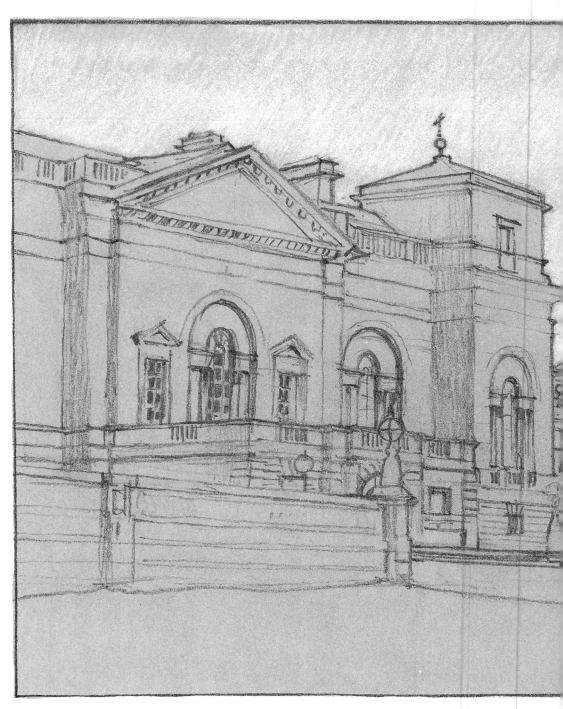

FIG 130 A composition involving
Holkham Hall, Norfolk cut off to the left.
Drawn on grey paper with the sky
lightened with white pencil

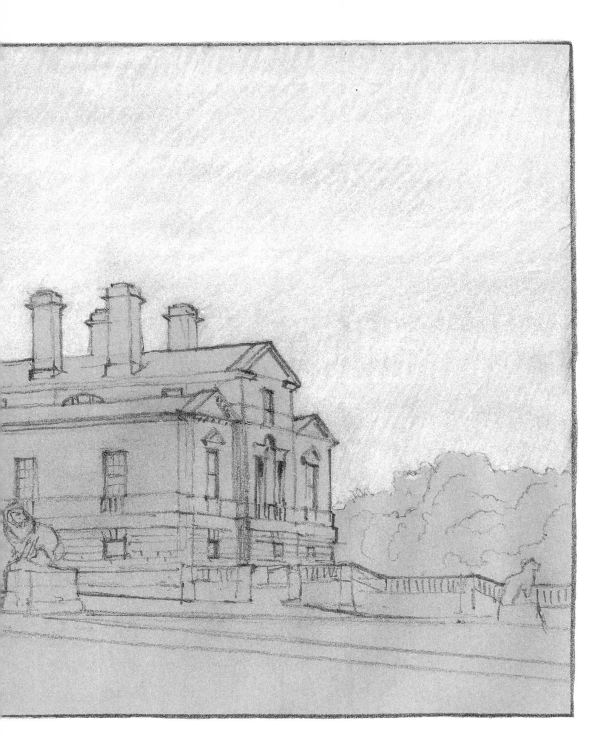

FIG 131 A sash window seen flat on

FIG 132 A three-quarter view revealing much more information than seen in Fig 131

102

FIG 133 A drawing of part of the
South Downs where the
abstract shapes involved begin
to become the dominating
characteristic

FIG 134 The drawn edge to a
composition can be
exceedingly helpful

FIG 135 Drawn with the changing light
as the main aim, the final compositional
shape was only decided upon half-way
through the development

can be modified as the drawing progresses and the final proportion
established in advance of finishing the drawing itself. By this means a drawn
composition can be made of a shape totally different to the sheet of paper in
the book or on the drawing board. Tall thin compositions are possible (Fig
136) or broad and narrow for a wide landscape (Fig 137).

A good composition is what you think best at that time. You may or may not
change your mind in the months to follow but your thoughts will have been
focused, and when visiting exhibitions you will see how others have fared and
what you too might try.

It is also helpful to write notes at the time of drawing. Information about
tones and colours can be helpful later. Personally I prefer to add notes at the
foot and sides of a drawing rather than on the drawing itself. They can be
more extensive and will not disfigure the picture.

There are some visual qualities which can be added, not so much by
thought but by the materials. Very rough paper and a very soft pencil will
produce a strong, spotted texture, particularly in a predominantly tonal

drawing (Fig 138). The hollows in the paper will remain untouched by the pencil. Similarly the matt side of brown wrapping paper and a medium soft pencil will produce a drawing with lines running through it for the surface is finely ribbed. A white pencil can be especially effective here, providing highlights in contrast to the mid-brown tone of the paper (Fig 139). If a white pencil is used by itself on a dark-toned paper, then the untouched paper becomes the dark areas while the pencil models all that is lighter (Fig 140).

A word of warning: if you try to use both light and dark pencils on a half-tone paper, give predominance to one or the other in any one area (Fig 141). Do not mix the two, for the actual pigments may produce a disturbing third quality when worked together.

FIG 136 A particularly tall composition involving the main tower of St George in the East, London, designed by Nicholas Hawksmoor

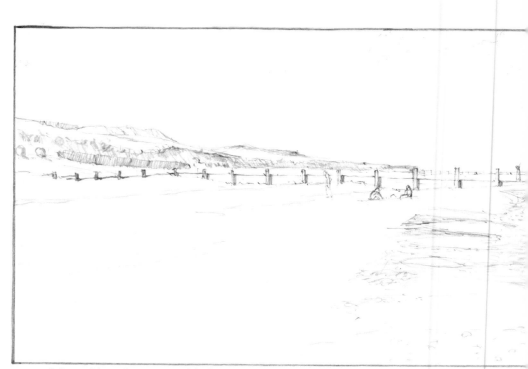

FIG 137 A broad beachscape could almost go on for ever

FIG 138 The combination of a very rough paper and soft pencil can produce a strong texture

FIG 139 Oranges, which have appeared earlier, drawn on brown wrapping paper and highlighted with white pencil

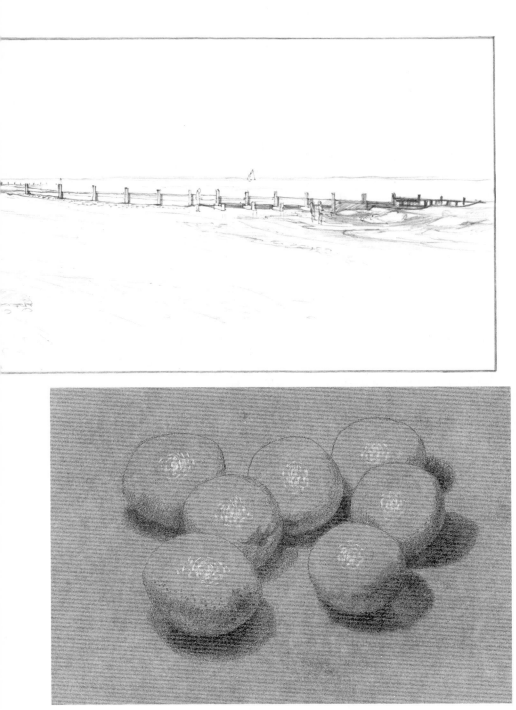

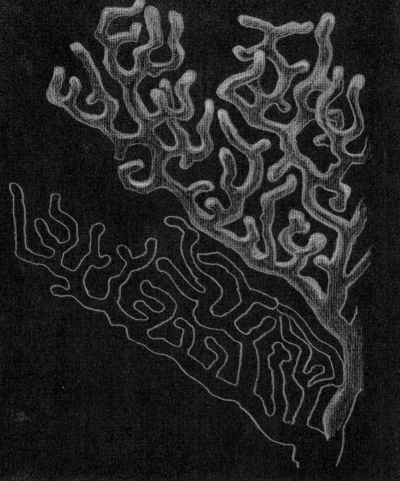

FIG 140 White pencil on black paper describing a pale coral structure against a dark background. Notice the first stage—seen unfinished in the bottom left area—was line alone. This was then developed with gentle shading and ultimately strongest white applied where the light showed up the form

FIG 141 An Egyptian carved wooden figure drawn by using both pencil and white pencil on grey paper. The part painted surface of the figure needed more than the single tone pencil alone could provide

108

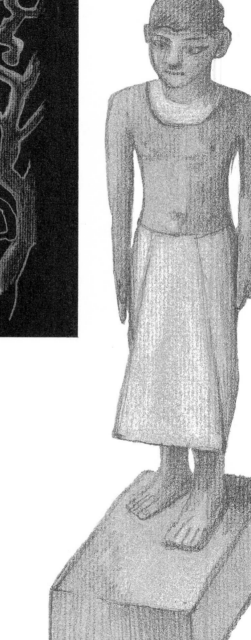

CHAPTER 9

Presentation

One of the joys of pencil drawing is that very quick, spontaneous drawings can be made. This is particularly useful when drawing outside and when subjects may be moving (Fig 142). A sketch book to hand, the pencil aimed, and you're off! No time for pondering and careful consideration of proportion and shape.

The drawings may capture some real qualities about the subject, but they may also be rather small and possibly incomplete (Fig 143). Back home it will be worth trying to re-draw the subject, adding some elements from memory and making a more complete picture. I do not recommend starting a drawing outside and later trying to continue it indoors, because if it goes wrong you've spoilt your original.

To work at a bigger size may well help, but there can be considerable loss of authenticity if the enlarging is done only by eye.

To enlarge a picture construct a grid on a piece of tracing paper. No actual measuring is needed. Use the diagonal of the chosen rectangle and sub-divide it as finely as the detail of the picture necessitates (Figs 144 to 149). This same grid can be repeated but at a larger (or smaller) size for the new work. It must be drawn very faintly, the diagonal (Fig 150) being extended till a suitable size is reached, the new rectangle completed and then sub-divided as before (Fig 151). You will then be able to transfer all the shapes from the original to the new drawing.

If you wish to enlarge only part of a picture, try this simple but very effective method. Cut an old mount in half, making two L-shaped pieces. Alternatively mark them on a large sheet of toned paper and cut them out (Fig 152); 7 to 10cm (3 to 4in) sides will be most useful.

Use these two L-shaped pieces of card or paper to lay over your drawing and by juggling their positions you will be able to select just what area or part you wish to be your new picture. Then proceed to scale it up as before.

By now you will be tempted to get one of your drawings on the wall (Fig 153). As well as your visual enjoyment, it is the best way to be your own critic. Old frames can be brought to life again and if turn clips are used at the back,

FIG 142 A very quick drawing made in a
sketch book

FIG 143 A page from a sketch book with
brief drawings which might be
developed later

FIG 144 The chosen rectangle

FIG 145 The first diagonal

FIG 146 The second diagonal

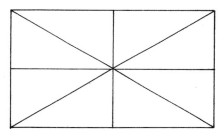

FIG 147 The vertical and horizontal making the quarters

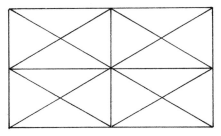

FIG 148 The diagonals within the quarters

FIG 149 The verticals and horizontals making 16 rectangles and completing the diagonals necessary to complete the grid

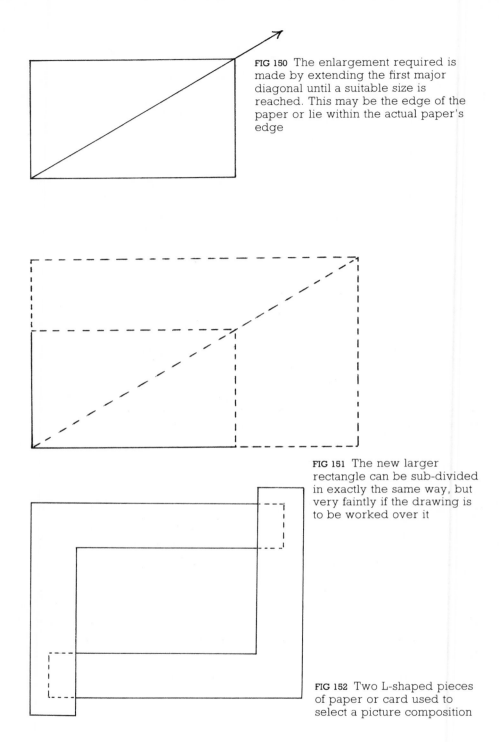

FIG 150 The enlargement required is made by extending the first major diagonal until a suitable size is reached. This may be the edge of the paper or lie within the actual paper's edge

FIG 151 The new larger rectangle can be sub-divided in exactly the same way, but very faintly if the drawing is to be worked over it

FIG 152 Two L-shaped pieces of paper or card used to select a picture composition

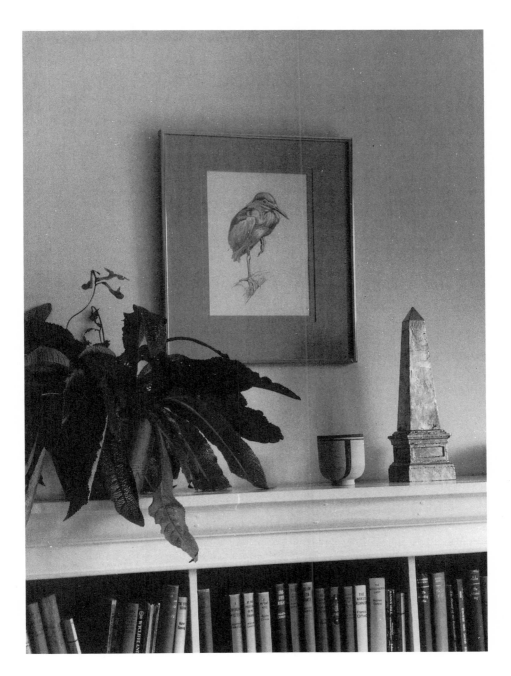

FIG 153 Drawing mounted and hung

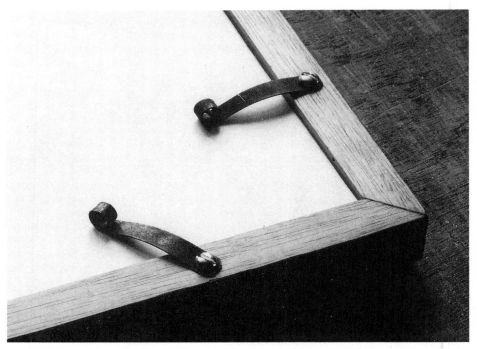

FIG 154 Turn-clips at the back of a wood frame providing simple access for picture changing

rather than pins, the drawings can be replaced easily; of paramount importance for the artist (Fig 154). Ready-made frames and those assembled from kits are available from many shops, but the latter will need glass and backing as an extra.

If the drawing is to be mounted onto the backing, the dimensions should be calculated from the paper edge rather than the drawing itself. If a mount is to be cut, the opening will condition the size. I suggest that the frame needs to be 16cm (6in) larger than the drawing/paper/opening on both dimensions. This will leave 8cm (3in) at each side, and for comfortable placing, slightly less at the top—say 7cm (2¾in)—with 9cm (3¼in) at the bottom.

When the paper is directly mounted on to the backing, add a pencil line 1cm (½in) away from the edge all round. It will add a little refinement (Fig 155).

But to draw and draw again is the first priority. As experience grows so too will personal choice and considered aims. Drawing is about observation—observation about thought—and thought about choice—and in the end how and what you draw is happily your choice.

The greatest joy comes from the fact that once begun there need be no end to the possibilities. The humble pencil has already been in use for several hundred years and I see no reason why it should not be with us for several hundred more!

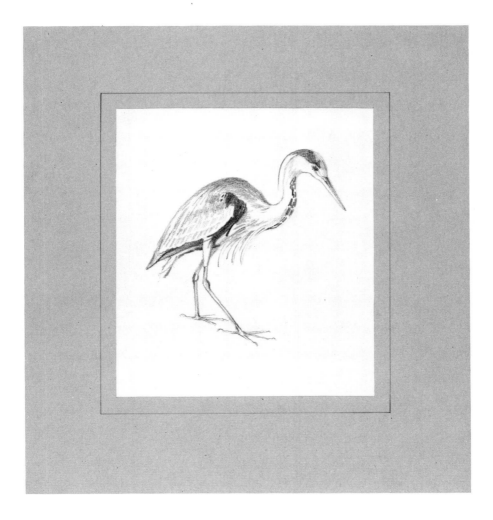

FIG 155 This drawing has been trimmed to size and then stuck, using spray glue, on to a piece of mounting card.

Note the card proportions with the top being slightly smaller and the bottom slightly larger than the sides

FURTHER READING

Pinter, Ferenc, and Volpi, Donatella,
 A Guide to Drawing, Dryad Press
Ball, Wilfred, *Sketching for
 Landscapes*, Dryad Press
Ball, Wilfred, *Weather in Watercolour*,
 Batsford
Gordon, Louise, *Anatomy and Figure
 Drawing*, Batsford
Gordon, Louise, *Drawing the Human
 Head*, Batsford
Croney, John, *Drawing Figure
 Movement*, Batsford
Ashwin, Clive, *Encyclopaedia of
 Drawing*, Batsford
Lancaster, John, *Basic Penmanship*,
 Dryad Press
Baker, Arthur, *The Calligraphy Manual*,
 Dryad Press
Furber, Alan, *Layout and Design for
 Calligraphers*, Dryad Press
Jones, Edward, *Painting People*,
 Batsford

INDEX

All page numbers in italics refer to illustrations